Draw **Fight** Scenes Like a **Pro**

Draw Fig

Lik

Jeff Johnson

ht Scenes
e a Pro

WATSON-GUPTILL PUBLICATIONS/NEW YORK

First published in 2006 by Watson-Guptill Publications,
A division of VNU Business Media, Inc.,
770 Broadway
New York, NY 10003
www.wgpub.com

Senior Editor: Jacqueline Ching
Editor: Lanie Lee
Assistant Editor: Katherine Happ
Designer: Kapo Ng@A-Men Project
Senior Production Manager: Hector Campbell

Text and illustrations copyright © 2006 Jeff Johnson

Contributing Artists:
Eric Conettie: 135 inks
Joaquim Dos Santos: 139 art
Steve Jones: 135 art
Scott Kolins: 40, 127 color, 129 art
Brandon McKinney: 131 art
Dan Panosian: 100,101 inks, 137 art 5, 10, 13, 52, 68, 142, 143 color
Andy Smith: 133 art

ISBN-13: 978-0-8230-1372-2

Library of Congress Cataloging-in-Publication Data:

Johnson, Jeff.
Draw fight scenes like a pro / by Jeff Johnson.
p. cm.
ISBN 0-8230-1372-3
1. Combat in art. 2. Cartoon characters. 3. Drawing--Technique. I. Title.
NC1763.C58J64 2006
741.5--dc22
2005028461

The principal typeface used in the composition of this book is Trade Gothic.

Printed in the U.S.A.
First printing, 2006
1 2 3 4 5 6 7 8 / 11 10 09 08 07 06

Acknowledgments

Writing this book took longer than I could have imagined, and it required the help of many people to finally whip it into shape. To everyone who was part of this strange process, I would like to tip my hat in sincere and humble thanks.

To Jackie Ching for her patience and understanding.

To Dave Johnson for letting me steal something from him twice.

To Sensei Dave for showing me the Way and teaching me the true meaning of Giri.

To all my friends who gave freely of their time, knowledge, and art: Steve Morris, Chuck Dixon, Scott Kolins, Brandon McKinney, Andy Smith. Steve Jones, Dave Draffin, Eric Conettie, Dan Panosian, Joaquim Dos Santos, and Chris Schenck. It couldn't have happened without you. You guys rock.

To Megan, who makes the sun shine brighter.

To my sister, the real artist of the family.

And finally to my mom, who put a pencil in my hand and showed me how to make the world a better place.

Contents

Foreword

The Fightin' Side of Me

They call it "action."

But let's call it what it is.

It's violence.

It's the shoot-outs and fistfights and beatings and murders and cosmic punch-ups that are probably the most consistent elements of comics over the course of their entire history. After romance and funny animal comics have faded away into the back pages of price guides, the core element of all comic books is conflict and resolution. The most common debates are "Who's the strongest?" or "Who will beat who in a fight?" It's the stuff of late-night fanboy conversations. It's the subject that fires up the comic message boards. And even though they'd never admit it, it's the source of heated debate in the offices of your favorite comic book companies. They're just *professional* fanboys, after all.

And the violent resolution of conflict goes back to the dawn of comics. *Krazy Kat* was a strip built around a mouse beaning a cat with a brick every week. *Popeye* rose to popularity by kickin' tail in epic fights that could last weeks. The largest part of Superman's appeal was the wish-fulfillment fantasy of every 98-pound weakling: to be the guy who could clean *anyone's* clock. This is even truer of Spider-Man, who *was* a 98-pound weakling until he became Marvel Comics's premiere scrapper. Jack Kirby, the undisputed king of comics, is best known for his powerful depictions of physical confrontations between gods and monsters. Smackdowns are even more central to mainstream comics these days, as the conflicts often result in the *deaths* of major characters.

There are shelves of books on how to draw comics. How to draw manga. How to draw men, women, robots, and monsters. The ins and outs of superhero anatomy. How to tell a story in comics. How to sell your work.

But no one has written a guide to the fine points of comicdom's most common feature: the *fight.*

That's been rectified now. And no one on this planet is more qualified to bring it to you than Jeff Johnson. I had the distinct pleasure of working with Jeff on a comic called *The Way of the Rat* at the now-defunct CrossGen Comics. The book was a period martial arts epic set in a mythic medieval China. It was a kung fu story. And Jeff's kung fu is strong, Grasshopper.

Jeff's a master of several martial arts and a serious dabbler in many more. He not only knows the moves but he can *make* them. The guy's a devoted practitioner in all things butt-whuppin'.

In addition to that, Jeff can draw. Not just fights either. He brings a comic page to life with deftly realized characters and sumptuous backgrounds. His costuming is a delight. His draftsmanship is sure and bold.

But it's in the area of depicting action that he really pulls away from the pack. His action scenes bristle with suspense and grace all at once. There's a flow to his encounters that's well thought out and skillfully executed. He considers body types and fighting disciplines when designing a character. Each character's martial style results in a different type of musculature and level of physical development. And he deals with all of that. Keeps himself up nights contemplating it. Jeff brings so much of his spirit and mind to bear on a project that it can get intense.

That said, he's an open and generous collaborator. At CrossGen we all had the rare opportunity of sharing a common studio and working closely together on our assignments. The collaboration with Jeff was probably my most involved. Due to his deep knowledge of, and enthusiasm for, the genre and setting of *Way of the Rat,* I relied on his participation tremendously and bowed to his judgment regularly. He was eager to help in plotting and had tremendous ideas for segues and changes and set-ups. Because of the nature of the martial arts formula, we had to contrive ways to insert fighting into each story. Each issue need-

ed a battle of some type. Jeff was instrumental in weaving these fights into the plotline seamlessly. Together, we created an ensemble book filled with tension and rising action leading, every six issues, to an awesome, bruising climactic fist fest.

And that's where my job got easy. The issues of *Rat* that were primarily concerned with combat were almost entirely left to Jeff to pace and plot. Who was I to choreograph a fight scene for this guy? We'd decide where the fight was to start and who was to win and the rest was pure Johnson.

So, those are his bona fides for authoring the book you have in your hands. There simply is no one more qualified. From rooftop superheroic mayhem to barroom brawls to barbaric swordplay to demigod throwdowns, Jeff's the authority.

And I don't say that just because he can kick my ass.

CHUCK DIXON,
safely locked in his office somewhere in Florida

Introduction

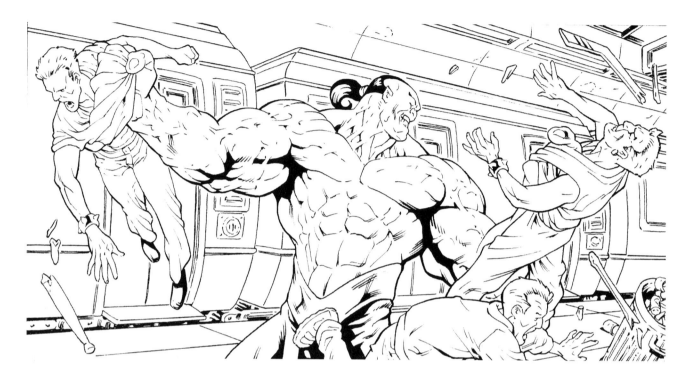

Even though a comic book fight scene is just one component of the whole story, it serves as a visual metaphor for the story as a whole. It is an illustrated guide to the narrative battle between the protagonist and the antagonist. The fight scene is not merely a random action; it must encapsulate and demonstrate the basic themes and conflicts of the story while advancing the entire narrative to its final resolution.

A well-drawn fight scene gives you a personal, immediate, and emotional connection to the characters in a way that no other storytelling device can. A fight scene can express the basic themes of the greater story and give you insight into the personalities and motivations of the combatants.

In the heat of a battle, characters reveal their true nature, and it is through their actions that they will define themselves. In other words, how a hero fights is as important as why the hero is fighting in the first place.

In this book we will explore what makes a believable and interesting fight scene. We'll learn how to give characters movement in a fashion consistent with their role in the story. We'll create believable environments within which their struggles can take place, and we'll learn how to make the reader care about the outcome of the conflict. We'll do this by looking at the following set of concepts, which, I believe, form the foundation of drawing any fight scene:

- Basics of figure drawing (specifically designed with the fight scene in mind)
- How to draw characters interacting in motion
- Illustrating the believable transfer of momentum
- Manipulating body mechanics to serve a graphic and narrative purpose
- Creating believable environments that accentuate the parameters of a conflict and also serve a narrative purpose
- Breaking down the fight scene in terms of the story and the stages of any conflict and its resolution
- Understanding the difference between an emotional and technical fight scene and how to use them to serve the narrative

A fight scene is a story within a story, and like any story, it relies heavily on personal perspective and aesthetic. Just as there is no right or wrong way to tell a story, the rules for drawing a fight scene are flexible and malleable to circumstance as well as to personal taste. The fundamentals of a well-told story and a well-drawn fight scene are the supporting architecture of personal expression.

This book is meant to be a guide toward understanding those underlying principles—the architecture—of a fight scene and to serve as a tool for applying those ideas and techniques to the telling of your own story.

So remember, the fight scene is not separate from the story, but the story itself, concentrated and stripped down. In the real world conflict is never best resolved with violence, but in a story, especially a visual story, combat is the most dramatic and rewarding problem-solving technique. An action sequence cuts through the quagmire of social niceties—it gets down to the meat and the heart of the problem. For the reader, it is much more satisfying to have a hero knock out the villain than to watch the two characters sit calmly and talk out their differences.

In the past, action comic books with their many colorful fight scenes have been much maligned. They have been called simplistic and gratuitously violent—accused of offering the reader clichéd and vulgar resolutions to complicated issues. But a fight scene can be much more than some senseless slugfest. It can be an elegant example of the struggle between good and evil. It can clearly illustrate the difference between right and wrong in bold and beautiful colors. It is through the crucible of conflict that the characters show us, most intimately, who they are and what role they play in the story. If viewed that way, action and fighting are no longer violent or juvenile, but revealing and transformative.

History of the Fight Scene

The illustrated fight scene has been around as long as man has been painting in caves. The battles between man and his prey have been splashed across cave walls in vivid colors. The weapons of the hunt, the techniques of the warriors, and the dramatic stories of their struggles were depicted in sequence. Long before the hieroglyphs we know today were fully developed, pictures of the victories of Egypt's first king were found crudely carved into stone.

The visual adventures of Odysseus and Hercules have survived the test of time in pottery and mosaic. Ancient Chinese battles, such as when thirteen monks rescued Prince Li and routed the Zheng army, were painted in detail on the walls of Shaolin temples. For centuries, images on Japanese prints and scrolls have glorified the skills of the samurai, from the samurai archer on the ancient Kasuga Gongen scroll, who is shown being attacked by a *kumade*—a long rake used to pull the samurai from his horse—to the 1185 Kuniyoshi print of the Battle of Dan-no-ura. They document the intensity of battle as well as specific techniques and styles of fighting.

Mythical and historical battles can often be metaphors for the conflicts in our own lives. The images of these stories not only entertain us, but also educate and inspire us. They teach us methods of victory and encourage us to fight our own battles with honor and grace. It's this inspirational quality, as well as its martial and historical significance, that makes the illustrated fight scene one of mankind's most popular and enduring art forms.

Here is an example of a Japanese woodblock print done in the Kuniyoshi style.

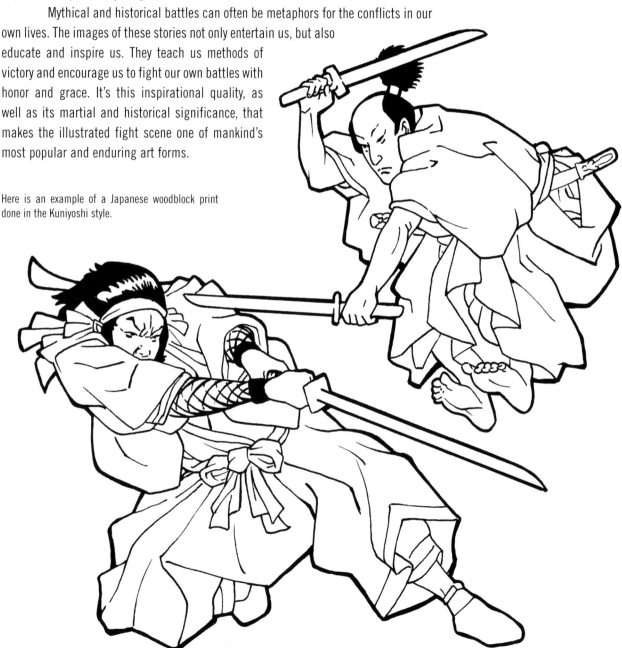

Chapter 1
Learning the Basics

Drawing a figure in combat is not like drawing a figure in repose—there are some concepts and skills that need to be firmly in place before you can move on to the specifics of drawing an actual fight scene. One of the driving ideas of creating a believable superhero fight scene is that your characters move in a natural and graceful manner.

In this chapter I will lay the groundwork for skills you will use in later exercises. I've designed the lessons to build on each other, and if they are taken out of sequence, you might slow yourself down or find some of the concepts confusing. All you need in order to master these lessons are a pencil, some paper, an open mind, and a lot of practice time.

Building the Skeleton

We'll begin with something simple—a stick figure. Everybody can draw a stick figure, or what we'll call "the skeleton." The skeleton comprises, literally, the bones of the drawing.

Practice by copying the skeletons on this page. It is the first step to creating exciting action figures and awesome fight scenes. The more you practice, the better you'll be.

Draw the spine first. The position of the spine suggests the general movement of the figure. Next, work on the oval shapes for the head, torso, and pelvis. Then add the lines for shoulders and hips. Attach your arms and legs, and now you have a skeleton!

Once you've mastered the examples on this page, practice drawing your own figures. Draw the skeletons in different poses: running, sitting, jumping, or even flying. Once you can draw the bones of a figure, the rest will come easily.

After you have drawn a few pages of stick figures, draw the actual bones on top of the stick figures. See how the lines and shapes of the stick figure match up to the lines and shapes of the human skeleton?

Move on to the next step only when you feel comfortable with drawing the skeleton.

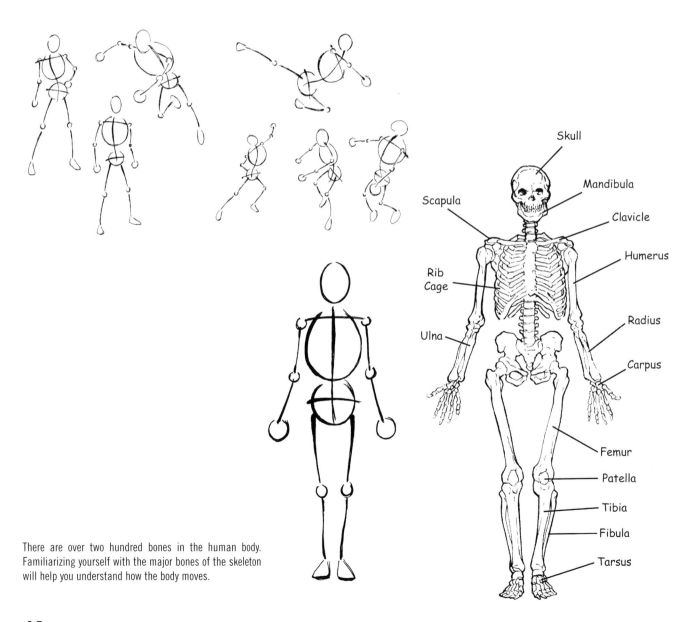

There are over two hundred bones in the human body. Familiarizing yourself with the major bones of the skeleton will help you understand how the body moves.

Constructing a Mannequin

This step is even easier than the first one. Now you will be drawing basic shapes: cubes, cones, cylinders, and spheres. How easy is that? Everyone can draw them.

Practice drawing your shapes from all different angles—45 degrees, 90 degrees, 360 degrees. Get comfortable moving these shapes around in space. Pay special attention to your cylinders.

Draw a cylinder coming right at you, from the side, and from every conceivable angle. The better you are with your cylinders, the happier you will be when you want to draw your action hero in midair, performing a roundhouse kick into the enemy's face. Play with your shapes so that they interact three dimensionally. In my example, you can see how I've given the shapes a relationship to one another. I overlap shapes so they exist on top of and behind one another. Learn to create the illusion of depth with your shapes and you will be able to design entire worlds!

Once you become comfortable with drawing these shapes from different angles and perspectives, you'll simply place them on top of your skeleton. This is your "mannequin." Learning to construct a believable mannequin will allow you to draw the human figure in any pose from any angle you can imagine.

Before you go on to the next step, I want you to add these basic shapes to all the skeletons you have drawn. The mother of skill is repetition.

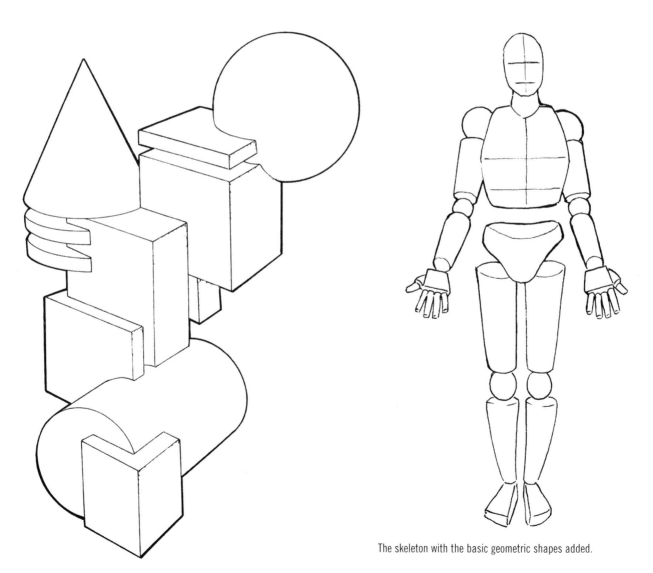

The skeleton with the basic geometric shapes added.

Anatomy at a Glance:
The Musculature

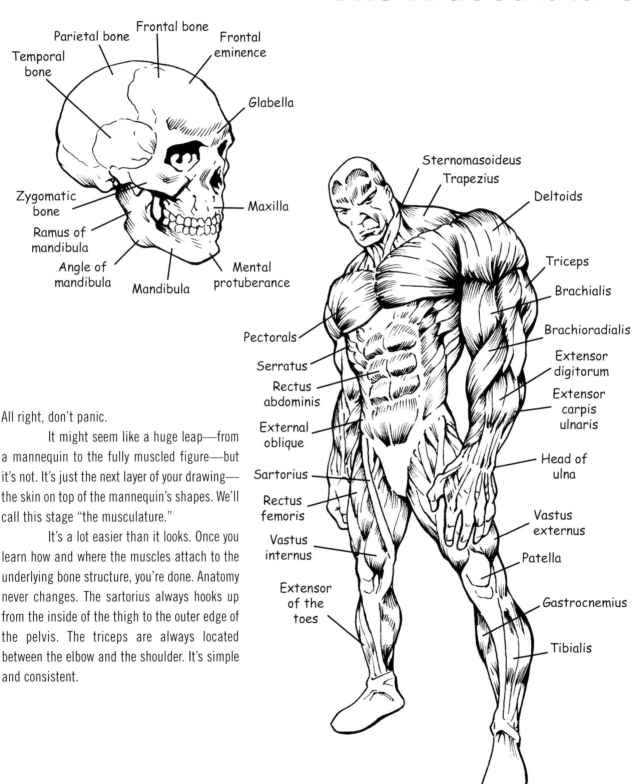

Parietal bone
Frontal bone
Frontal eminence
Temporal bone
Glabella
Zygomatic bone
Maxilla
Ramus of mandibula
Angle of mandibula
Mandibula
Mental protuberance

Sternomasoideus
Trapezius
Deltoids
Triceps
Brachialis
Brachioradialis
Extensor digitorum
Extensor carpis ulnaris
Head of ulna
Vastus externus
Patella
Gastrocnemius
Tibialis
Pectorals
Serratus
Rectus abdominis
External oblique
Sartorius
Rectus femoris
Vastus internus
Extensor of the toes

All right, don't panic.

It might seem like a huge leap—from a mannequin to the fully muscled figure—but it's not. It's just the next layer of your drawing—the skin on top of the mannequin's shapes. We'll call this stage "the musculature."

It's a lot easier than it looks. Once you learn how and where the muscles attach to the underlying bone structure, you're done. Anatomy never changes. The sartorius always hooks up from the inside of the thigh to the outer edge of the pelvis. The triceps are always located between the elbow and the shoulder. It's simple and consistent.

The true test of your knowledge of human anatomy is how well your figures move and interact with one another.

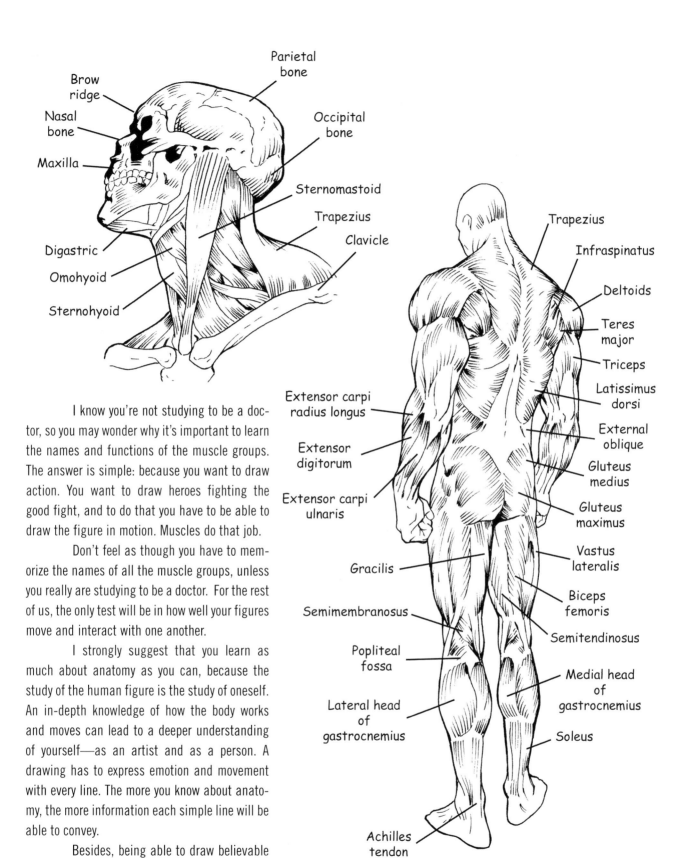

Parietal
bone

Brow
ridge

Occipital
bone

Nasal
bone

Maxilla

Sternomastoid

Trapezius

Digastric

Clavicle

Omohyoid

Sternohyoid

Trapezius

Infraspinatus

Deltoids

Teres
major

Triceps

Latissimus
dorsi

External
oblique

Gluteus
medius

Gluteus
maximus

Vastus
lateralis

Biceps
femoris

Semitendinosus

Medial head
of
gastrocnemius

Soleus

Extensor carpi
radius longus

Extensor
digitorum

Extensor carpi
ulnaris

Gracilis

Semimembranosus

Popliteal
fossa

Lateral head
of
gastrocnemius

Achilles
tendon

I know you're not studying to be a doctor, so you may wonder why it's important to learn the names and functions of the muscle groups. The answer is simple: because you want to draw action. You want to draw heroes fighting the good fight, and to do that you have to be able to draw the figure in motion. Muscles do that job.

Don't feel as though you have to memorize the names of all the muscle groups, unless you really are studying to be a doctor. For the rest of us, the only test will be in how well your figures move and interact with one another.

I strongly suggest that you learn as much about anatomy as you can, because the study of the human figure is the study of oneself. An in-depth knowledge of how the body works and moves can lead to a deeper understanding of yourself—as an artist and as a person. A drawing has to express emotion and movement with every line. The more you know about anatomy, the more information each simple line will be able to convey.

Besides, being able to draw believable anatomy is crucial when you want the reader to accept that your character is lifting a tank or flying faster than a jet plane.

Using these drawings as a guide, go back to your mannequin sketches and draw in the appropriate muscles. Once again, it's important to feel comfortable with this step before moving on to the next one. You must walk before you can run—and you definitely have to be able to run before you can fly.

The depth and detail you want to show in the muscles you draw is entirely up to you. You'll create your own personal aesthetic. Some artists like to show every muscle straining with ropey tension, while others prefer to show the shapes of the underlying anatomy. Your style is yours to decide—but you can't make a stylistic choice until you have a firm grasp of the fundamentals.

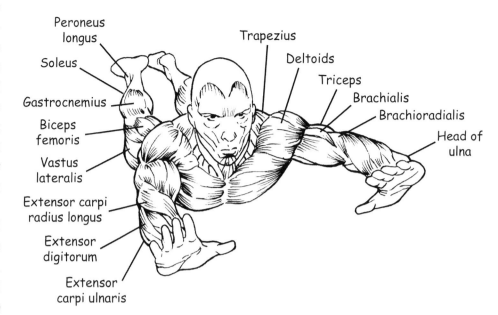

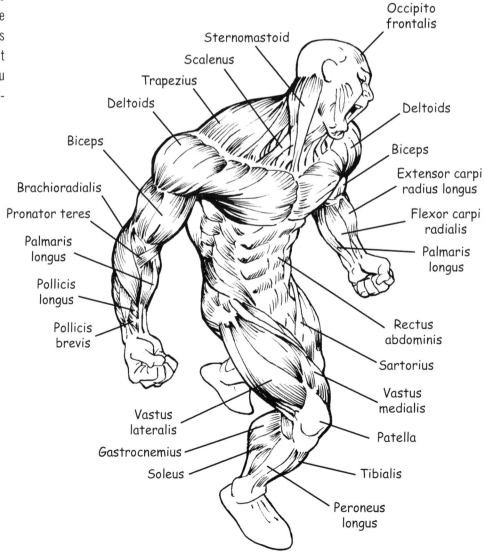

Simple Drapery

Once again, this step seems a lot harder than it truly is.

 We'll simplify things by adding a new basic shape to your geometric library: the arrow. Learn to see and draw the arrow as a three-dimensional shape. Unlike the other basic shapes you've practiced, the arrow should be malleable. Allow it to bend and twist. Give it some life and what I refer to as *intention*.

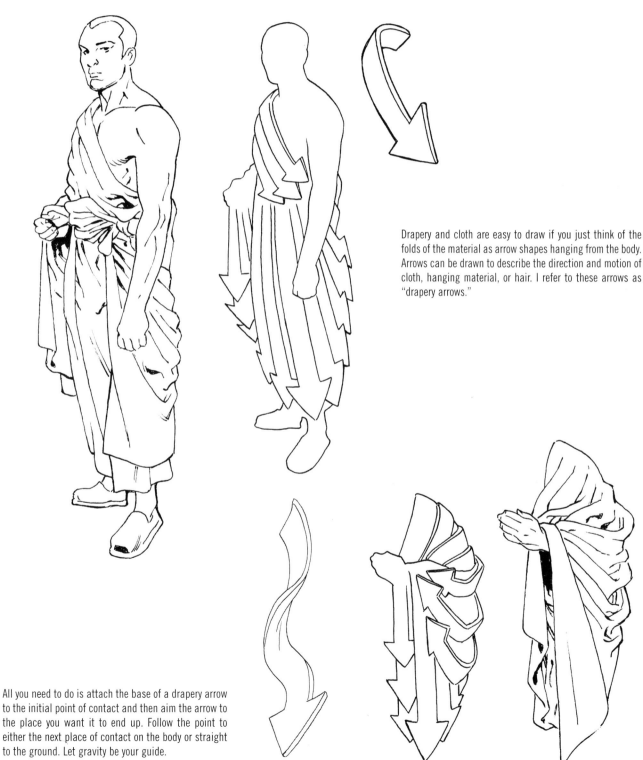

Drapery and cloth are easy to draw if you just think of the folds of the material as arrow shapes hanging from the body. Arrows can be drawn to describe the direction and motion of cloth, hanging material, or hair. I refer to these arrows as "drapery arrows."

All you need to do is attach the base of a drapery arrow to the initial point of contact and then aim the arrow to the place you want it to end up. Follow the point to either the next place of contact on the body or straight to the ground. Let gravity be your guide.

When dealing with layers and bundles of material, draw the arrows so that they fold under the shape of the figure or pile up on each other. Think of the arrow as a solid shape that has weight, mass, and a specific length.

Experiment with different sizes and thicknesses of the arrows to see how they affect the nature and texture of the material.

Go back to all your practice drawings and add dressing to your musculatures. Give them capes and jackets and hanging belts. Design cool outfits. Try different materials and styles.

Be sure that you are comfortable drawing the three-dimensional arrow shape from any angle.

The drapery arrow is the first of many different kinds of arrows that we will be using in this book. I'll describe the rest of the arrows a little bit later, so for now, just get comfortable with this one.

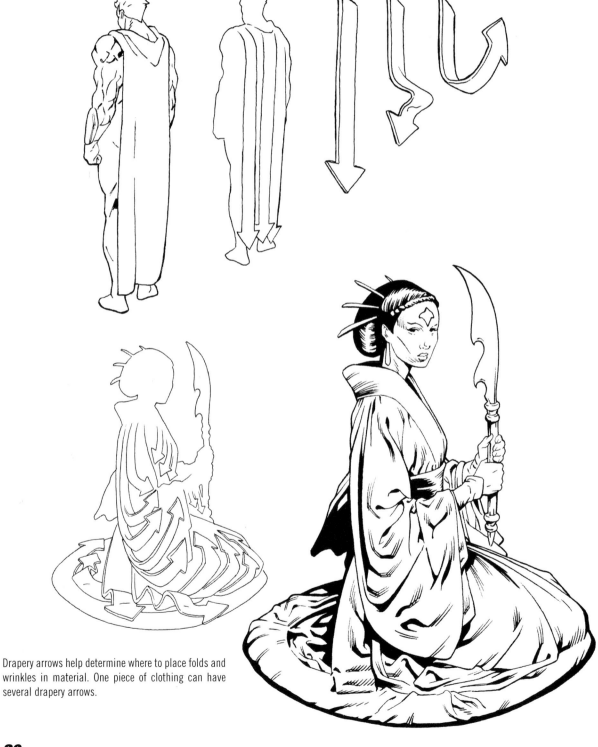

Drapery arrows help determine where to place folds and wrinkles in material. One piece of clothing can have several drapery arrows.

Putting It All Together

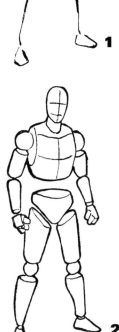

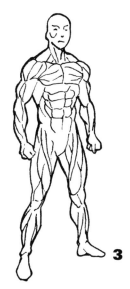

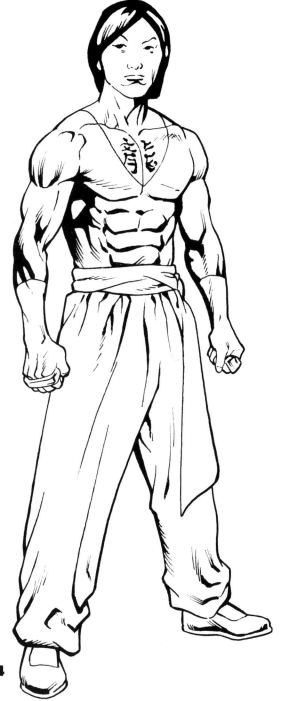

Let's review our steps so far:

Step 1: The Skeleton. See how easy that part is now? Just a bunch of lines put together on paper. It's like writing but with an alphabet of bones.

Step 2: The Mannequin. Draw in basic shapes and your drawing has dimension, weight, and even a little character.

Step 3: The Musculature. The deltoids attach to the shoulder sockets. The abs connect to the upper and lower torso. Your character is starting to look like a human. A naked human, true, but a potential person nonetheless.

Step 4: Simple Drapery. Some skin and some clothes, remember your drapery arrows, and *voilà!*—a finished drawing. A fully formed character to fight in your upcoming adventures.

I think it's important at this point to mention the influence your emotional state will have on your final drawing. You can think of this as a *preliminary* step that guides the other steps. If you're drawing a hero, you should think heroic thoughts. What you see in your mind's eye will come out on the page. You must, in essence, *become* the hero. This may seem esoteric and weird, and maybe it is—but if you practice your basics, it will become automatic. With a firm grasp of your fundamentals, what you imagine will become real on the page in front of you.

1

2

3

4

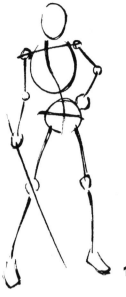

The true test of any skill is to apply it outside the parameters in which it was learned. We've been drawing men up until this point, but once you understand the fundamentals of drawing the male figure, you already understand the fundamentals of drawing the female figure. Apart from some proportional differences, the basic structures are all the same. Only the personality of your drawing changes.

Step 1: It's still the skeleton. There are some differences between the male and female skeleton, but these are mainly about body proportions. For instance, the female skeleton's shoulders are not as wide, the hips flare more, and the center of gravity is lower. These may seem like major differences, but they're really not. As you learn to build your characters from the ground up, you'll learn to take these shifts of balance and structure into consideration before you even touch pencil to paper. Once again, if you can picture it in your head, it will come out on the page.

Step 2: The same mannequin. The only changes to be made are with the geometric shapes, which will be determined by the body proportions.

Step 3: The exterior anatomy doesn't change much so it's the same basic musculature.

Step 4: Once again, some skin and some clothes and you're done! She's strong and confident, and she will kick evil's butt.

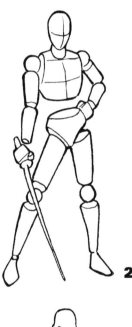

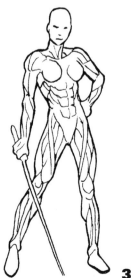

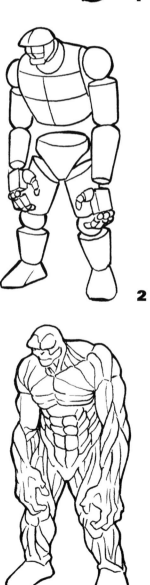

Now that you've gotten pretty good at drawing normally proportioned humans, let's stretch your horizons a bit. Let's draw a character that is a little sad, a little bit tragic, and perhaps even a little bit monstrous. Is he a hero or is he a villain? Only history will know for sure.

Step 1: It is still the skeleton, just slightly exaggerated. Hunch the shoulders, elongate the arms, and add some emotion to the posture.

Step 2: It is always the mannequin, which just fits on top of the skeleton.

Step 3: We'll use the same musculature, just adapted to fit the elongated skeletal structure.

Step 4: It's the final layer. Veins and too much skin! Not to mention a hang-dog expression.

This guy has lots of personality—but you probably won't invite him home for tea.

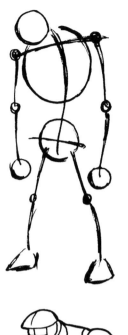

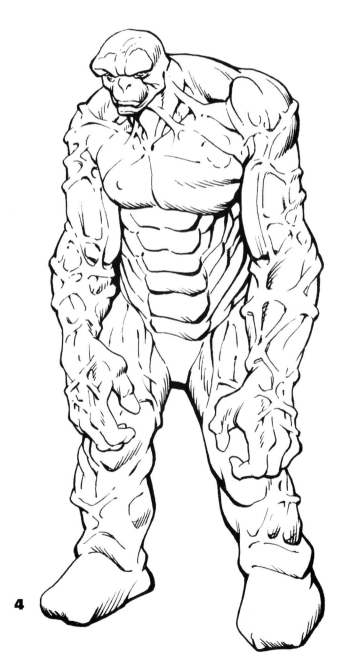

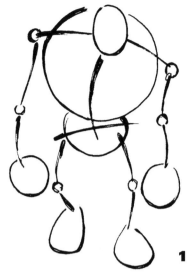

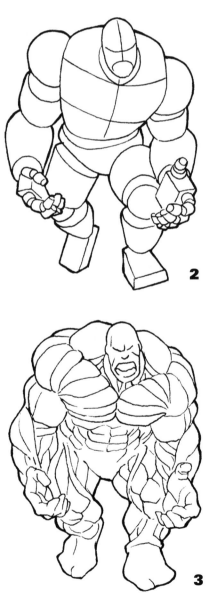

Once you have a strong grounding in the basics of form and function, then you can let your imagination go wild. Really push the envelope on what you believe are reasonable proportions for a human being. Exaggeration is liberation; free your mind and your art will follow.

Step 1: Still a basic skeleton, but with a lot more character. The head is smaller, the hands and feet are oversized, and the chest is going to be huge! This guy is clearly bad to the bone!

Step 2: The mannequin is also enlarged on this guy. Bigger shoulder spheres and massive cylinders for the arms and legs.

Step 3: Adapt and apply your basic musculature to fit this character's frame. See how the same anatomical connections are made no matter whether the underlying structure is tiny or gigantic?

Step 4: Give him some pants and some spit coming out of his mouth and you've created a serious problem.

Look at this guy! He's totally going to ruin someone's day!

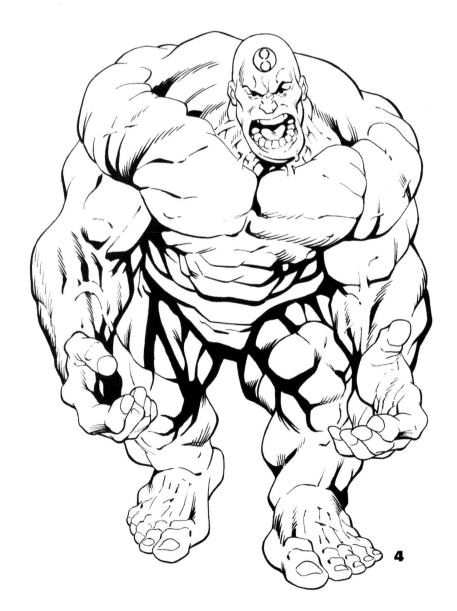

Moving the Figure:
The Action Arrow

Now let's add a new element to your figure drawing—*movement*. If your characters don't move—or, more accurately, give the illusion of movement—then who's going to care?

If we are going to create compelling and interesting fight scenes, we have to have our characters fly off the page. To help us communicate this sense of movement, we are going to use the "arrow" again. Since the arrow is a universally recognized symbol that instantly evokes a sense of direction and motion, the reader automatically responds to its visual message.

To begin, draw a quick gesture line to indicate the general feeling and direction of your figure's intended action. This line will represent whichever part of the body is the focus of that action, be it the arm, leg, spine, or even the centerline of the figure. We'll call this the "action line."

Extend the dimensions of the action line to create an outline of an open arrow shape. Make sure the arrow shape is large enough to encompass the general area for your figure. This is your "action arrow." It is the space in which your character's action will take place.

Lastly, draw your figure using the shape of the action arrow to help guide the body posture and graphic design of your character.

The shape of the arrow subconsciously directs the reader's eye.

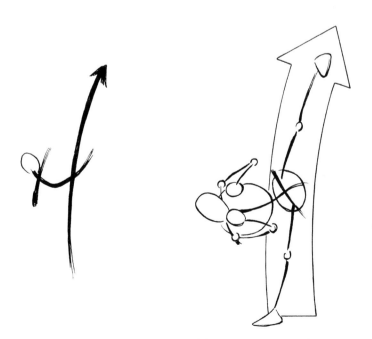

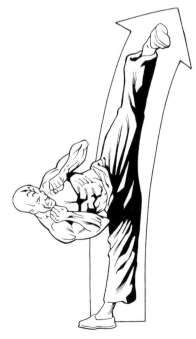

1 To begin, draw a quick gesture line.

2 Extend the dimensions of the action line to create an outline of an open arrow shape.

3 Draw the figure using the shape of the action arrow as a guide.

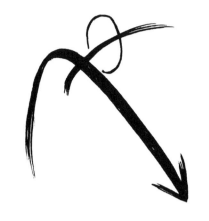

By using the dimensions of the underlying action arrow shape to inform and support your drawing, you incorporate that shape's inherent qualities of direction and motion into your figure.

Don't try to cram your figure into the confines of the action arrow. It would be confusing and limiting if the figure conformed exactly to the shape of the arrow. To achieve the desired effect, the character's body posture only has to be reminiscent of the arrow shape.

Also, do not include the action arrow as part of the finished drawing. It is just a tool to reinforce what the drawing is trying to communicate. The action arrow is part of the drawing's underlying support structure, like the skeleton or the mannequin, and should be invisible in the final version.

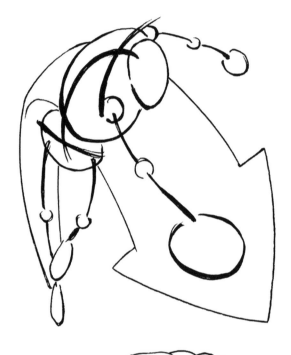

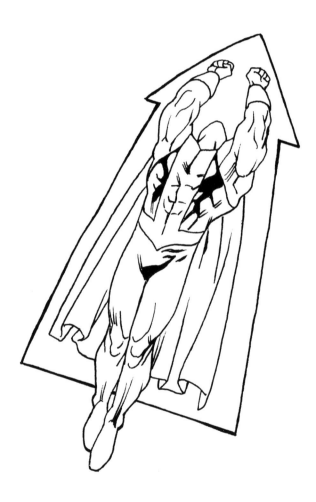

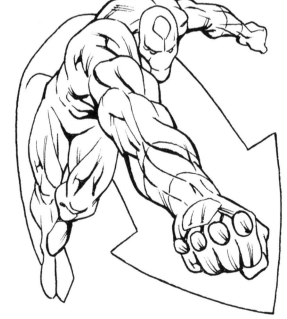

By using the arrow symbol to guide the posture and shape of your figure, the finished drawing will have an inherent sense of direction and movement.

Cloth in Motion

Now let's add some movement to the drapery arrow you drew earlier. These arrows can show a lot more than just how material folds around the body. By aiming them away from the ground, they can point to where the body was a moment before and hint at what action just occurred.

The drapery arrow helps to illustrate a character's position in space, as well as describe a recent past and a possible future. Movement and motion are the keys to excitement and drama. This is where we start learning how to move our characters through space and, strangely enough…through time.

For a character to be interesting, he or she must have a potential future and a believable past.

Study the illustrations below. Even though these are both relatively static drawings, the temporal quality of the drapery arrows give them the illusion of movement.

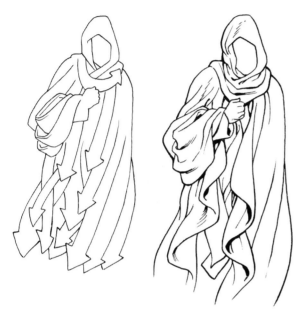

Left: With all the drapery arrows drifting to the left (as shown in the illustration), we get the feeling that this character is being blown along by a strange wind.

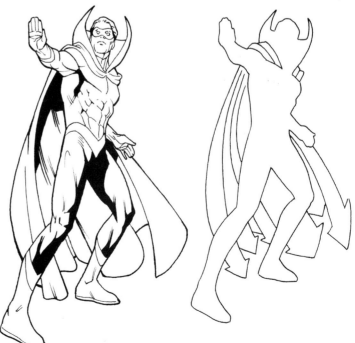

Right: Here we have a character that has suddenly turned to ward off some attack. The drapery arrows point to where he was standing a moment before.

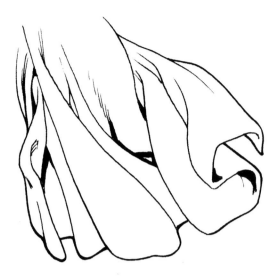

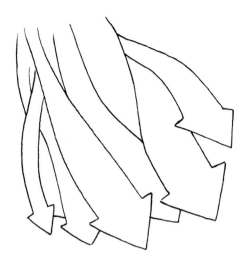

The drapery arrow is an excellent tool to help you create a believable fourth dimension for your characters, in other words, a life and a history. By giving the drapery itself a life and a history, we create a more complete illusion of movement. With the drapery arrows, you can illustrate simple cause and effect. Any dramatic action made by a character will express itself through whatever clothing that character may be wearing.

This delayed reaction of energy, through a connected material, not only describes what type of action just occurred but also its speed and intensity. By adding the illusion of movement through time, we can give our characters lives beyond the single moment captured in a drawing. Giving them a fourth-dimensional quality makes them seem more real and enhances the illusion that they have a life beyond the page.

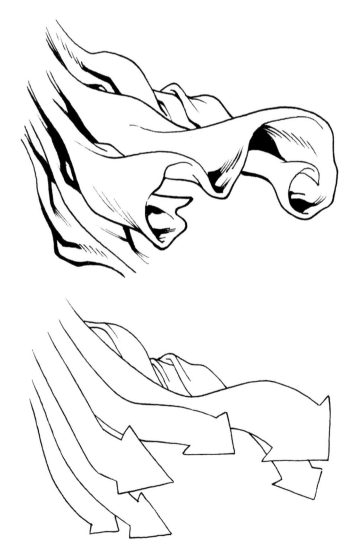

Drawing the Figure in Motion Through Time

Here is an example of how to use the action arrow and the drapery arrow in conjunction to give a character both a past and a future. The underlying shape of the action arrow implies a forward motion through space. We definitely get the feeling that this character is just passing through. His posture and graphic design reveal clear intention and a hint of a destination just off the page.

The drapery arrow points back to the character's origin. It indicates his previous position, and from the effect on the jacket's material, it's obvious that he's moving pretty fast.

Combining these arrows gives the character an active history and an immediate future. He seems to be held frozen in space and time, captive on the page, trapped between here and there. Learning to capture this kind of temporal tension will serve you well later when we begin choreographing fight scenes. Controlling the reader's perception of time is as important as creating the illusion of movement.

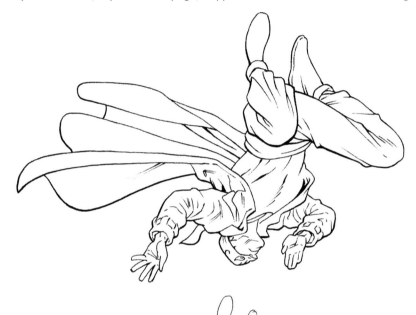

Center: The action arrow points in the direction of the action.
Bottom: The drapery arrow points to the ground on a static figure but points to a previous position when a figure is in motion.

Figure Drawing in Action: The Side Kick

Now let's practice drawing the figure in motion. Except for adding the action arrow to the beginning of the process, the steps are basically the same as drawing a static figure.

Notice that while I may draw all the muscles taut and flexed in the musculature stage, when it comes to the finished drawing I only emphasize the muscles that are actually being used during the movement. There is nothing wrong with drawing a super muscular character who is always flexed and totally shredded, but there is really nowhere to go from there. It's like ending every sentence with an exclamation point. It quickly loses its impact. I have found that a drawing looks more natural and, therefore, more believable when only the muscle groups necessary for the movement are flexing.

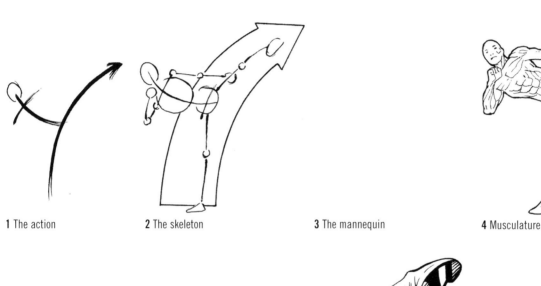

1 The action **2** The skeleton **3** The mannequin **4** Musculature

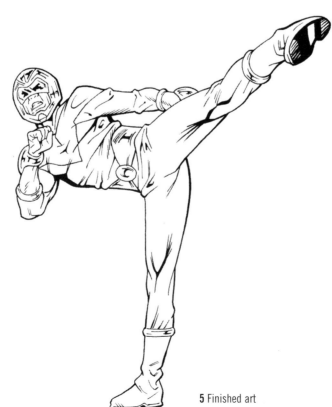

5 Finished art

The Jumping Side Kick

The only difference here is that now we've added some drapery to the costume. See how the hanging cloth points to where our character must have been just a moment before. By using the drapery arrow we now have a character moving fluidly through four-dimensional space.

At this point you might feel inclined to skip some steps and go straight to the finished drawing. I would strongly suggest that you don't. Train yourself to draw every stage; then you will eventually be unstoppable. I firmly believe that the true joy of art is in the process of creation, not the possession of the final product. I still draw the skeleton and the mannequin and the musculature before I get to the final stage. Sure, I go through the steps pretty fast, but that's from years of practice. I never skip ahead. Each and every drawing has something to teach you. Slow down, breathe, have fun.

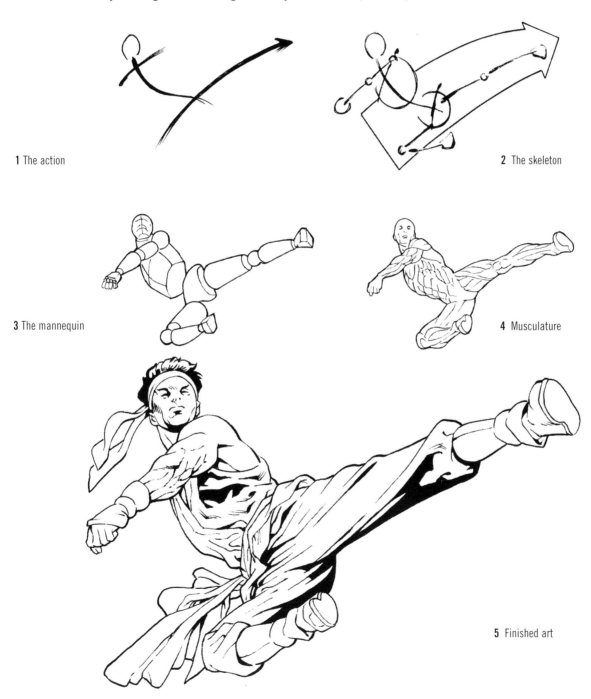

1 The action

2 The skeleton

3 The mannequin

4 Musculature

5 Finished art

The Foreshortened Jumping Side Kick

The trick to doing a truly dramatic action scene is to engage the reader. There are many ways to emotionally involve the viewer, but one of the best ways is to point the action right at them. Threaten them. Place them in harm's way.

This is easy to do. Just aim your three-dimensional action arrow toward the reader. If it appears that the next drawing will actually hit you in the face, well then, that's pretty darn interesting.

After properly aiming your action arrow, just follow your basic steps. Add the drapery arrows pointing backward into the past. It should feel as if the character is leaping straight out of the void and into our world.

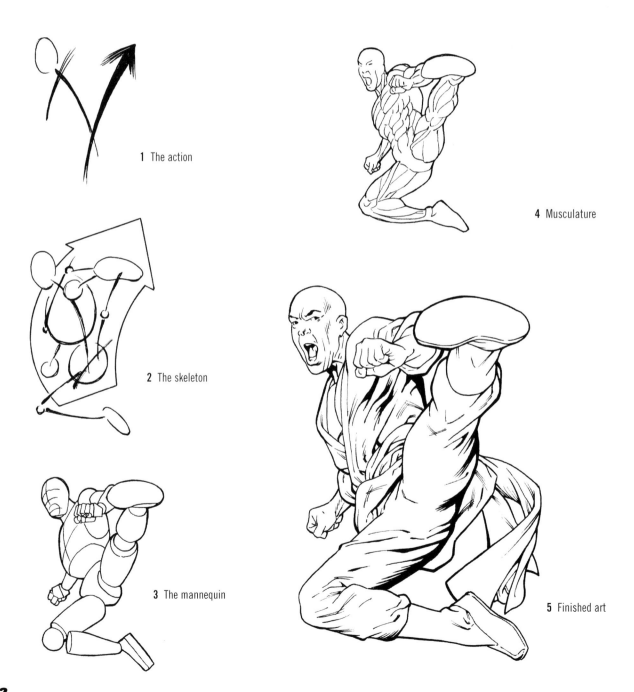

1 The action

4 Musculature

2 The skeleton

3 The mannequin

5 Finished art

The Foreshortened Lunge

Learning how to create an emotional connection with the reader is paramount to telling a good story. Your characters should appear as if they are leaping off the page, and the reader should believe that they will. Your art must captivate the reader.

 Draw this page a few different ways. Try different degrees of foreshortening. Make the angle of the leap more extreme. Perhaps you could even sharpen this kitty's claws. Experiment with making this drawing more uniquely your own. Add your own personal flair. Make him jump right off the page.

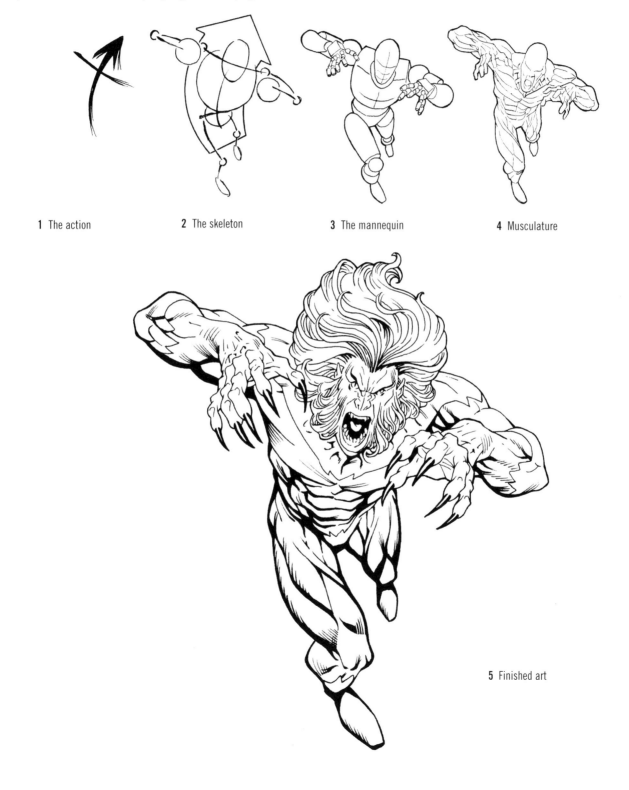

1 The action **2** The skeleton **3** The mannequin **4** Musculature

5 Finished art

The Moment Before the Strike

Let's take a step back from the in-your-face action. In this drawing we see the moment before the strike. The action arrow of the figure is actually pointing backward as the character winds up for the blow. The arm is cocked, and it is loaded with potential energy.

If you can successfully create the moment before an action, then you can hopefully get the reader to fill in the subsequent mental image. If you've done your job, the readers will draw your pictures with their own imagination, and you will have given your drawing a fifth-dimensional quality. I refer to this phenomenon of spontaneous reader interaction as fifth dimensional because it happens outside of conventional time and space.

This is a very important concept in creating an engaging fight scene. The reader must mentally fill in visual blanks with his or her own pictures. What you chose to draw must also include what you chose not to draw. The fifth dimension of your drawing is not just an emotional connection, but also a creative one.

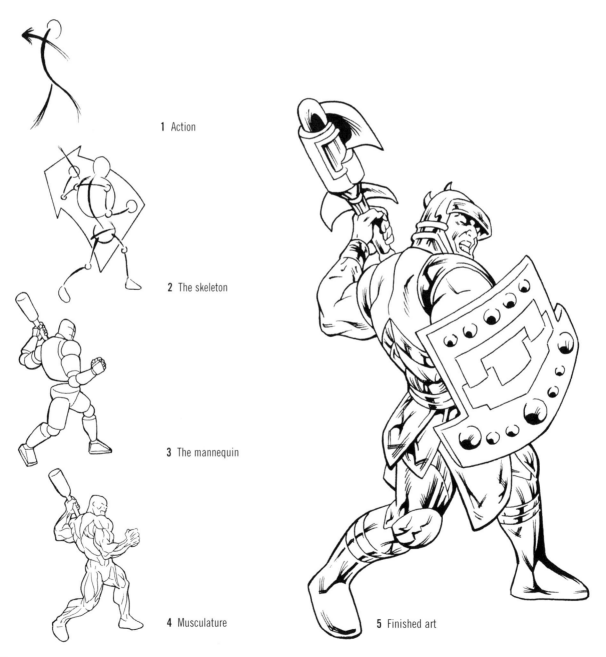

1 Action

2 The skeleton

3 The mannequin

4 Musculature

5 Finished art

Using Photo Reference

There are many things and actions that you are not going to know how to draw. Very few people are blessed with a photographic memory, so the use of reference becomes necessary, especially if you want to draw believable superhero fight scenes. The trick to using photo reference is not letting it bog you down. Let it be a beginning point for your drawing. Your job is not to draw a hyper-realistic copy of a picture but to use the knowledge gained by the reference to produce a more believable drawing.

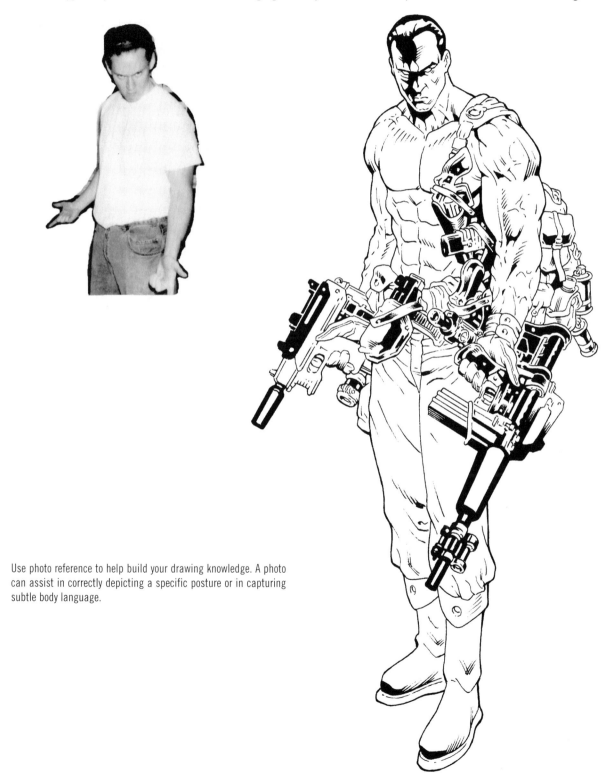

Use photo reference to help build your drawing knowledge. A photo can assist in correctly depicting a specific posture or in capturing subtle body language.

Don't just trace. Use the photograph as a starting point, then apply the same steps you would while drawing something straight from your head. This way, not only do you get a mechanically accurate drawing, but you also increase your knowledge of how the body moves and operates. Learning how to draw the figure, especially the figure in motion, is an ongoing and lifelong process. Besides, the very process of taking a picture flattens out the image, and if you trace an already distorted picture, your finished drawing will look flat and strangely unnerving.

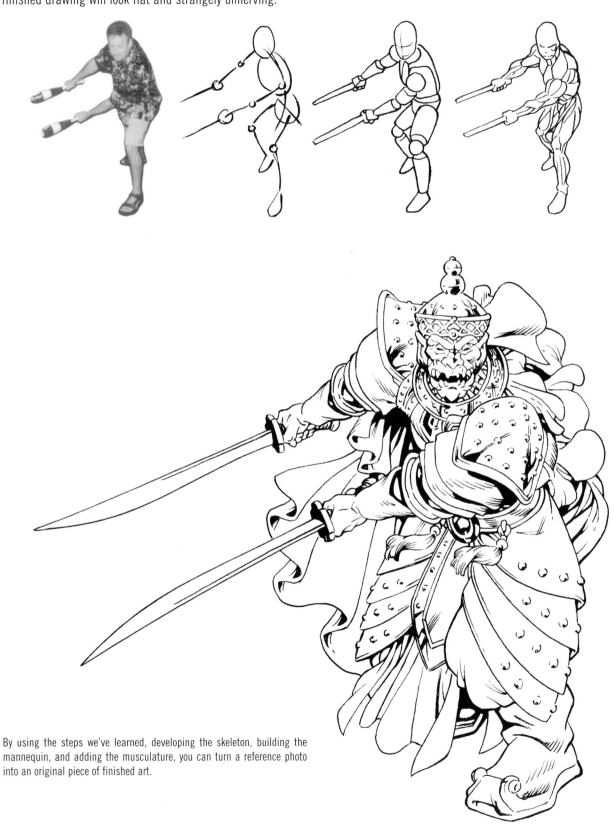

By using the steps we've learned, developing the skeleton, building the mannequin, and adding the musculature, you can turn a reference photo into an original piece of finished art.

Photo Reference Exercise

On this page, I've shown the photograph and the final, finished drawing. For practice, fill in all the missing steps. Then try using the same photographs to create entirely different drawings. Try using the same poses but greatly exaggerate all the proportions. Go crazy with it.

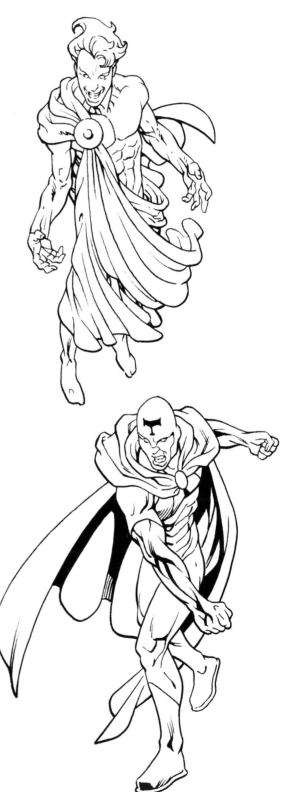

Final Exercise

I cannot stress enough the necessity of practice. On these pages are some drawings in various stages of undress. Work them forward and backward through the process before going on to the next section. Apply all the lessons from this chapter. Change the drapery on these characters. Change their body types and experiment with exaggerating their proportions. Try to get these drawings to live in four dimensions. Try to instill your drawings with a sense of impending action. Get your characters to breathe, move around, and really live.

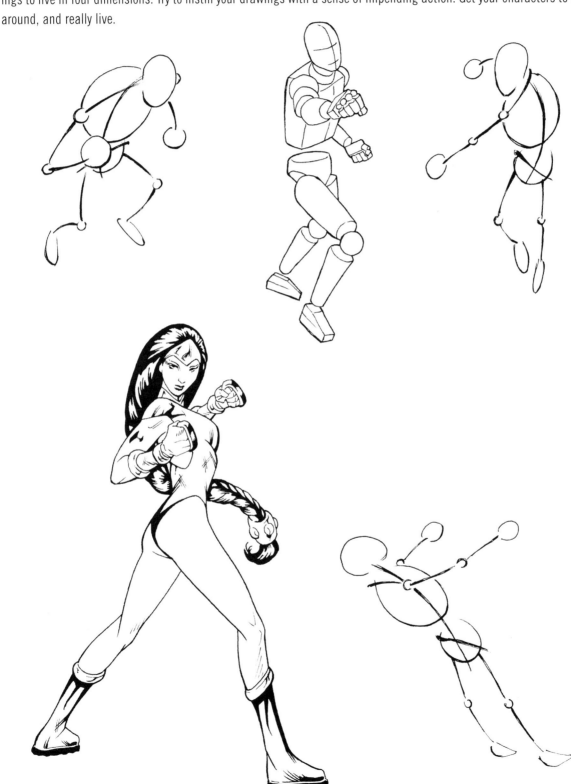

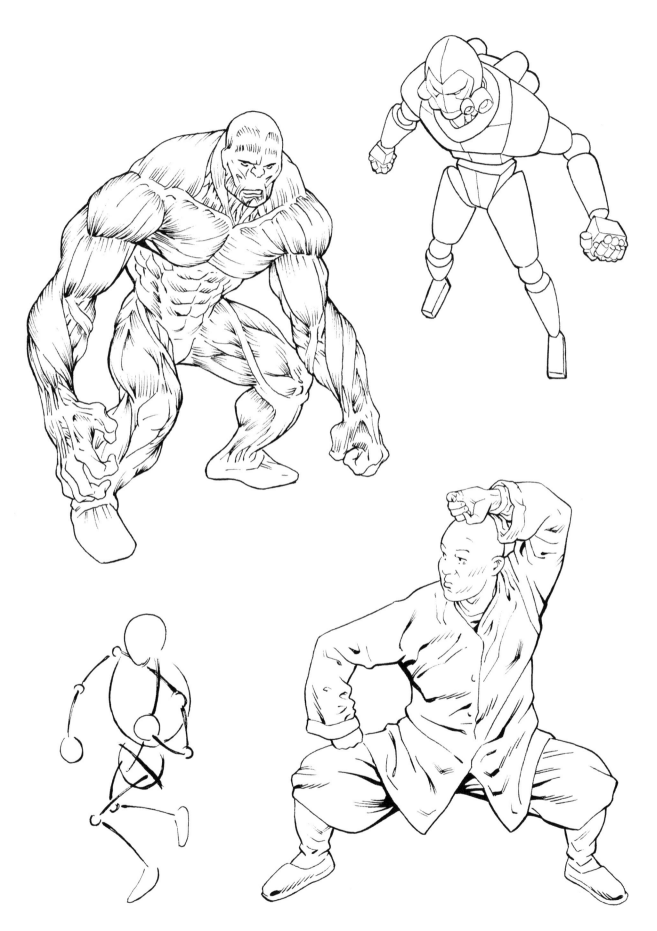

Chapter 2
Comparative Martial Arts

This chapter is not meant to be a comprehensive catalogue of the world's martial arts. To list them all would require several volumes. There are nearly as many styles of combat as there are reasons to learn a fighting art in the first place.

This is just a brief overview of a few different styles to demonstrate that each martial art has its own character and personality. The specific movements of any martial art are indicative of that particular art's attitude toward violence and the resolution of conflict. The techniques of a character's chosen style will show as much about them as their visual design. How a character moves and responds to threat reveals who that character is as a person, and punctuates his or her ideals with action.

For example, a villain will have moves that are violent and lethal, whereas a hero with a code against killing will not have moves that maim or kill in his list of techniques—what we will refer to as a "physical lexicon."

A straightforward and aggressive disposition will naturally lead a character to a harder martial style such as karate or wing chun, where the goal is to incapacitate your opponent as quickly and decisively as possible. A more circular and gentle personality will be drawn to a softer martial style such as aikido or tai chi, where the emphasis is placed on blending and harmonizing with an attack.

A character's choice of martial style is a physical manifestation of his or her inherent nature. An individual's Physical Lexicon is more than just a list of predetermined responses to various attacks, it is also a road map to understanding a character's general philosophy.

The physicality and body type of a character will also be a factor in what kind of moves a character employs. A large character who is superstrong and invulnerable will have a different relationship to battle than one who is lithe and acrobatic. A lighter, more agile person with a proclivity for jumping might pick a style such as Tae Kwon Do or wushu, whereas a heavier body type might be drawn to a more grounded style, such as boxing or jujitsu.

What characters believe, what they stand for, and what they are capable of is exemplified by how they choose to move through the world. In a comic book fight scene, movement is characterization and actions always speak louder than words.

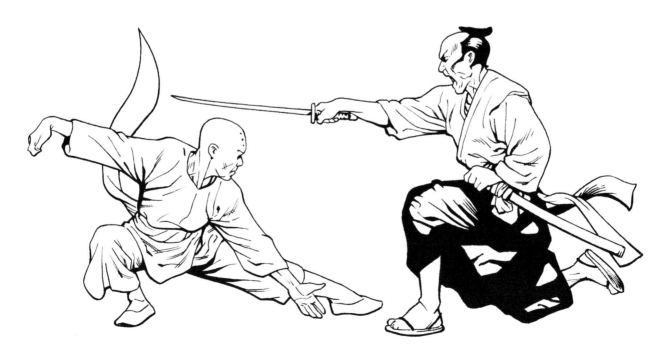

Aikido

Aikido was founded in the early twentieth century by Morehei Ueshiba. It is a very effective system of joint locks, throwing, and pinning. The techniques of the style are circular, and at its philosophical root, aikido is a quest for internal and external harmony with nature. A character who practices aikido will be as concerned with spiritual development as with vanquishing an opponent. The ultimate goal of aikido is the resolution of conflict without the escalation of violence.

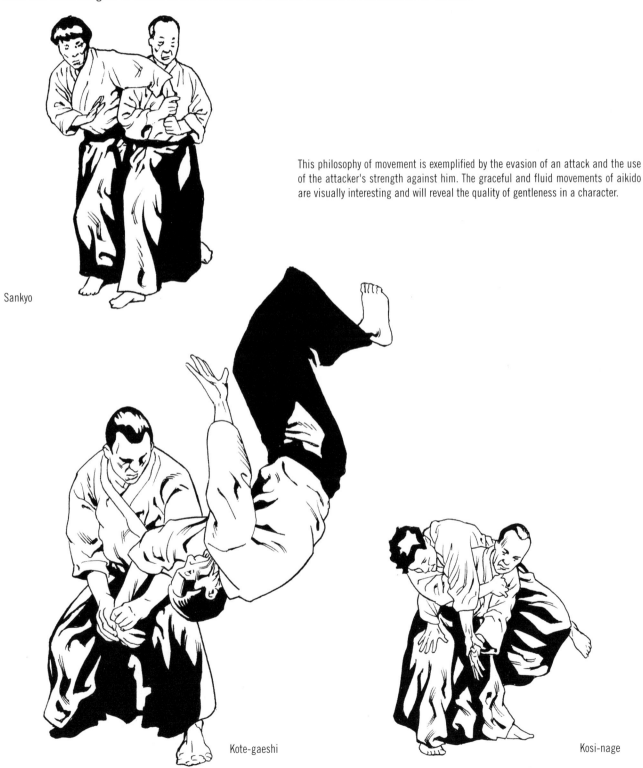

This philosophy of movement is exemplified by the evasion of an attack and the use of the attacker's strength against him. The graceful and fluid movements of aikido are visually interesting and will reveal the quality of gentleness in a character.

Sankyo

Kote-gaeshi

Kosi-nage

Boxing

Though sometimes brutal, boxing is a gentlemanly form of combat with rules and regulations with a certain formality. It is often referred to as the "Sweet Science." The match ends when one combatant is unconscious, can't continue to fight, or the predetermined number of rounds are over. So even though it is a very effective fighting system, with the trained boxer being adept at using his entire body to create tremendous punching power, none of the actual techniques are intended to be lethal.

A character drawn to boxing as a martial style might have an aggressive personality, but he will not be a killer.

There is no kicking or grappling in boxing, so a character who chooses this style will probably be inclined to stay on his feet and duke it out face-to-face.

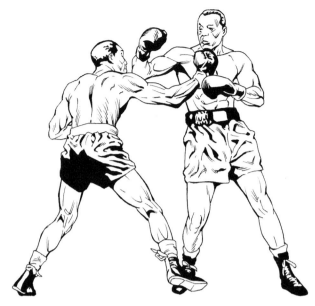

Boxing is a more brutal form of combat, especially in comparison to aikido and other martial arts. Blows are employed until one's opponent is rendered unconscious.

Brazilian Jujitsu

The origins of jujitsu can be traced back as far as the eighth century, and while jujitsu can be literally translated as the "Gentle Art," its techniques are powerful and deadly. The older style of jujitsu focused on destroying an opponent completely with scientific precision.

In modern jujitsu, the goal is still the ultimate defeat of an opponent but the level of intensity leans more toward incapacitation than annihilation—submission instead of death. The basic techniques of jujitsu are primarily throws, chokes, and joint locks. It is a style based in a thorough understanding of leverage and an intimate knowledge of body mechanics.

In the early 1900s, Carlos Gracie adapted this ancient martial art into its most effective and popular incarnation yet. Brazilian jujitsu is a style that works against any opponent, regardless of his size or training.

A character who uses jujitsu will be willing and eager to grapple with an opponent. While probably proficient at striking, a jujitsu practitioner will prefer to take any conflict to the ground.

A wide range of personalities will be drawn to this system of movement. Though some philosophical qualities are inherent in the very choice of jujitsu, the true nature of a character will be revealed by the severity of his technique. Does a character use an arm bar to submit an opponent or does that character just break the arm? Will he use a choke to render an attacker unconscious, or will he choke someone to death?

Joint locks, chokes, and grappling are important aspects of Brazilian jujitsu, in which the emphasis is on incapacitating, not killing, your opponent.

Karate

The word *karate* loosely translates as "Empty Hand," and it is primarily a martial art of fighting with bare hands and bare feet. It was developed on the Okinawan islands during the Japanese invasions of the Satsuma Dynasty, when the occupying armies banned the possession of any weapon or bladed farming implement. This left the native islanders literally empty-handed.

Since the islanders were denied the use of any weapon, the goal of Okinawan karate was to kill the invaders with single blows from the islanders' hands or feet. They pounded their knuckles and fingertips into hard surfaces, building up calluses and making them as deadly as any blade.

A karate practitioner's movements will be direct and lethal. A character using karate will be single-minded and goal-oriented. Though there are jump kicks and some very beautiful movements in karate, a person using this martial art will employ an economy of movement and a straightforward philosophy: one strike, one kill.

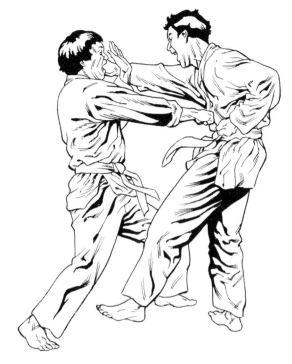

Karate

Muay Thai

This indigenous fighting system of Thailand is a vicious and extremely dangerous style of combat. A Muay Thai practitioner uses his knees, elbows, and even the shins to cause devastating effects.

Before modern rules were introduced, competitors would fight wearing crude boxing gloves made of hemp, which were often dipped in glue and coated with ground glass.

A person fighting with Muay Thai will use his entire body as a weapon and seek to overwhelm an opponent with a barrage of attacks. Though fewer contestants die in matches now, the techniques of Muay Thai are brutal and often lethal. A character practicing this style will probably not have many qualms about killing.

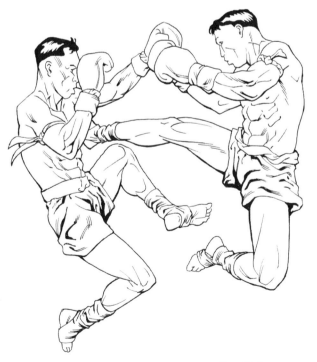

Muay Thai

Kung Fu

Kung fu is the broad term used to refer to the enormous collection of Chinese martial arts. It is commonly translated as "sustained effort or skill." The origins of kung fu are shrouded in antiquity, but it has existed in China for thousands of years. Throughout its turbulent past, China has been plagued by foreign invaders and civil wars. As a result of those struggles, a myriad of fighting systems has been developed over China's long history.

The different styles and philosophies of kung fu are as varied as the needs of the personalities of the people who created them. Their movements can be soft or hard, passive or violent, gentle or cruel. Below are a few examples of some various styles.

Pa kua was created near the end of the Ching Dynasty. Its movements have been described as subtle and mysterious. The pa kua stylist practices eight different angles of attack and continuous circular footwork. He uses mostly open palm techniques and low practical kicks.

Wing chun is thought to be the only kung fu style developed by a woman. It is a highly direct and aggressive martial art that wastes no time or effort on extraneous movements. It relies on speed and the practice of simultaneous defense and attack. By controlling the centerline of an opponent's body, the Wing Chun practitioner is always taking the shortest distance to the target.

Hung gar has its roots in the Shaolin animal forms, particularly the "tiger fist system." It is known for its low stances and powerful hand techniques. While the deep stances may make it slower than other styles of kung fu, they help the experienced hung gar practitioner deliver punishing power. It is an honest, straightforward martial art that promotes moral rectitude.

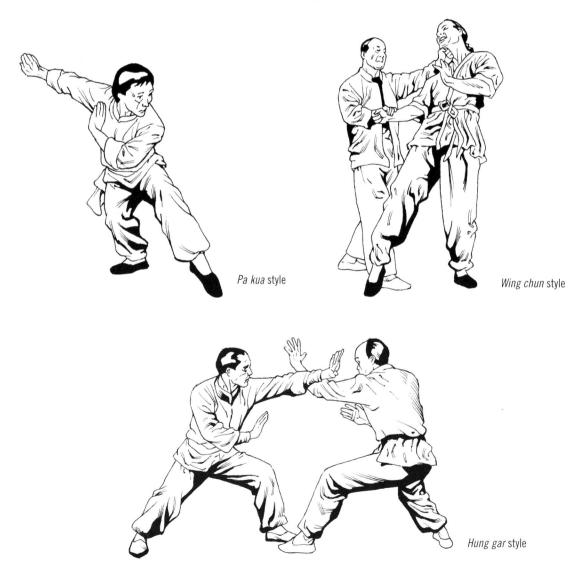

Pa kua style

Wing chun style

Hung gar style

Tibetan white crane kung fu is famous for its high kicks and elaborate footwork. The white crane stylist is an expert at keeping an opponent off-balance with fast and often confusing counterattacks. Like the other styles based on the movement of animals, white crane emulates not just the actions of the animal, but its attitude as well. A character practicing this kind of kung fu must be agile and comfortable in the air.

Chang chuan (or *quan*), or "long fist," is an open and honest style. Its followers believe that the best fighter will win without any tricks or deception. This attitude is exemplified by its expansive movements. The stances are strong and balanced. The kicks and punches are fast and graceful. A character using chang chuan will most likely be an idealist.

Bak mei, or "white eyebrow," kung fu is a short or middle-hand system. Its movements are soft and fluid until the moment of contact with the opponent, which is when they become hard and sharp. The phoenix fist is designed to hit the vital pressure points like the penetrating tip of a spear. This style promotes cleverness and the application of sudden power with precise timing.

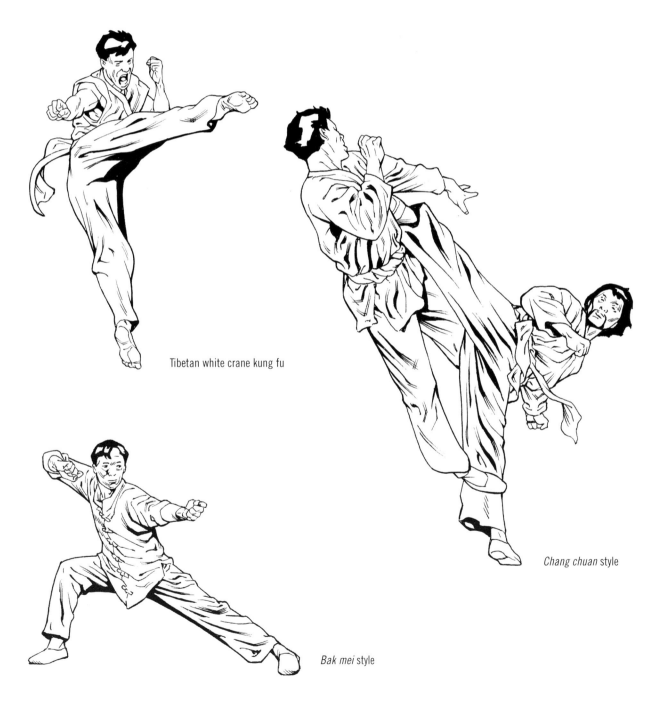

Tibetan white crane kung fu

Chang chuan style

Bak mei style

Shaolin kung fu dates back more than a thousand years, to when Bodhidharma, a holy man from India, founded the Chan sect of Buddhism in the Shaolin temple on the Songshan mountain in China. Over the years, the temple became a refuge for outlaws, retired generals, and several expert fighters. These influences—combined with the strenuous tradition of wushu, practiced by the monks in between long hours of sitting in meditation—formed the foundations of many modern martial arts throughout the world (Plum Blossom, Monkey, Five-Animal Play, Luohan Boxing, Long Arm, The Weapons, Drunkard's Boxing, Flying Dragon, to name just a few).

Standard Shaolin training includes: *Daozaibei*—headstands without any support, jumping and running with iron tied to the legs, hanging upside down using only the feet; *Zhizuaquiang*—boring through the wall with a finger, crushing walnuts on the head; and *Shangdiaogong*—hanging from a tree with a rope around the neck.

Shaolin kung fu embodies a profound Oriental philosophy. For the Shaolin monk, hard training and perseverance are the only true ways to cultivate moral integrity.

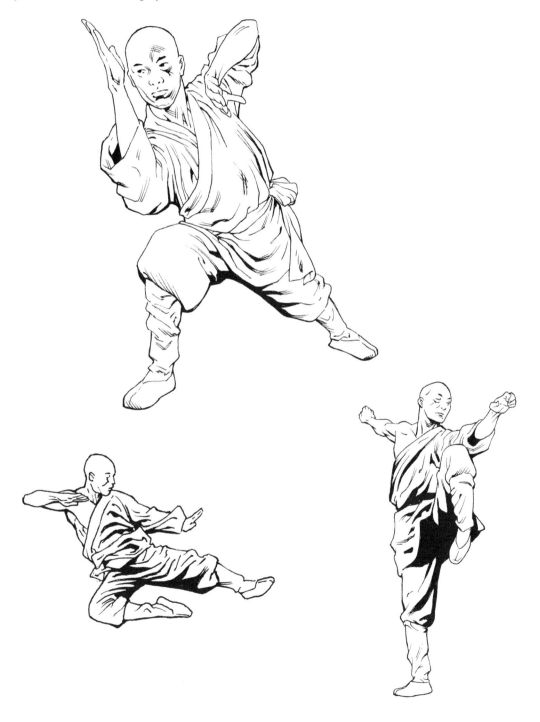

Tae Kwon Do

Tae Kwon Do is the Korean style of empty-handed combat based on a nearly two-thousand-year-old art known as *Tae Kyon*. At one point near the end of the tenth century, Tae Kwon Do training was mandatory for all young men, but by the sixteenth century the study of this traditional style dwindled in popularity until the art was only practiced by Buddhist monks. During the Japanese occupation of Korea, between 1907 and 1945, the study of martial arts was banned and many Tae Kwon Do practitioners were forced into exile in China and Japan. After the liberation of their homeland, they returned to Korea, adapted many kung fu and karate techniques into their system, and reintroduced the style.

After years of Japanese occupation, the newly formed Korean government officially sponsored Tae Kwon Do as part of its effort to bolster national identity. It is now one of the world's most popular contact sports.

Tae Kwon Do is dominated by kicks and aerial combinations with an emphasis on power and precision. A character using Tae Kwon Do will be very agile and capable of high jumps and tricky acrobatics. Tae Kwon Do has an inherent flair that will reflect a large personality.

A character using Tae Kwon Do will be very agile and capable of high jumps and tricky acrobatics.

Weapons

All weapons have a specific purpose and personality. A character uses a particular weapon that is in accordance with the needs of his personality. With this in mind, I've divided weapons into two categories: edged and non-edged weapons. This is basically a distinction between lethal and non-lethal weapons. Though a non-edged weapon is perfectly capable of killing someone, it is not expressly designed to cut the flesh of an opponent. While the use of an edged or bladed weapon doesn't automatically lead to death, its very nature makes it more dangerous. A non-edged weapon can be just about anything from a tool used to grind rice to a rope or even a scarf. In fact, many martial arts use ordinary household items to surprising effect. Here are just a few of the more common non-edged weapons.

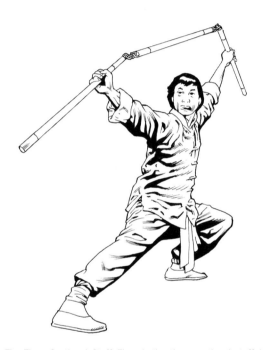

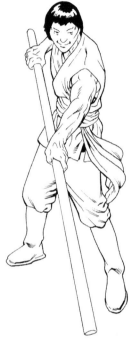

The Three-Sectional Staff. Though the three-sectional staff is an extremely difficult weapon to master, it is effective in close- and long-range combat. With its multiple sections, this weapon can be used for striking, choking, disarming an opponent, and even unhorsing cavalry.

The Staff. From the "long pole" of Wing Chun to the short "jo" of aikido, the staff is the most common weapon in all martial arts. It can be found in most styles, from the ancient Indian arts to the most esoteric kung fu. The staff is an incredibly versatile weapon, good for defense and offense. It can be used as an accurate thrusting weapon for both long- and short-range linear attacks, and its sweeping circular motions can generate devastating power.

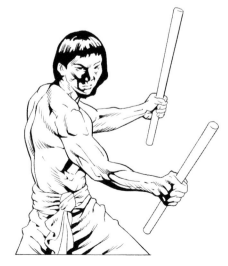

Twin Fighting Sticks. Escrima is a martial art from the Philippines that uses two hardwood sticks. In the hands of a trained escrimador, these sticks can be used for defense and attack with blinding speed and bone-crushing force.

The blade is not only a deadly weapon, but a powerful metaphor. Its razor-sharp edge is unforgiving and leaves no room for error. A character using a bladed weapon demonstrates a certain attitude of seriousness and finality toward combat. But even under that general umbrella, different kinds of blades have unique qualities, and they exemplify different character traits. Here is a sampling of some classic bladed weapons.

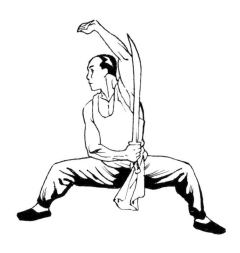

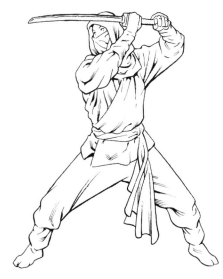

The Chinese Saber. This is a large weapon that yields flowery movements. The saber user requires total body integration to move the heavy saber effectively. Once mastered, the saber is an excellent offensive and defensive weapon.

The Shinobigatana. This is the short sword of the ninja. It is a weapon that is suited to close indoor fighting and the fast-draw technique of pulling and cutting in one simultaneous movement.

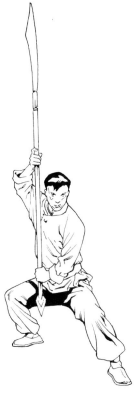

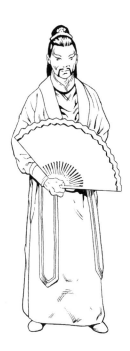

The Bladed Staff. The halberd, spear, and naginata are a few examples of this popular weapon. With the added range and leverage of a staff, these bladed weapons are truly formidable. The killing zone of a naginata can be up to a twelve-foot radius, with the practitioner being able to place the cutting edge either close to the body or at the weapon's full extension with just a shift of the hand position.

The Chinese Bladed Fan. The fan is a very elegant and aristocratic weapon. Anyone using this weapon will most likely be genteel and graceful. Use of this particular weapon will require your character to be very fast and proficient at dodging.

Inventing Martial Arts and Weapons

Once you have a rudimentary understanding of basic fighting styles and what their different movements reveal about an individual's personality, you can start to create techniques and weapons that suit the needs of your characters.

Let your imagination go and create your own martial arts for the characters shown on these pages. Give them goals, attitudes, and histories. If you make your creations real for yourself, then they will become real for your reader.

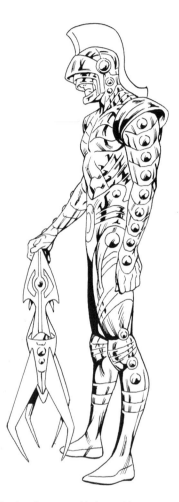

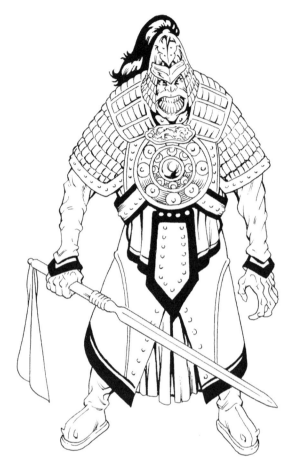

Here we have a demon with a variation on a Chinese straight sword. Because of his long arms, this weapon will be extremely effective at both thrusting and slashing. What style of movements might he favor?

Here's a four-prong blade used by a conqueror from another world. What kinds of movements might this weapon demand? Is it offensive or defensive? What sort of character would use this weapon? Where does this person come from and what is his history? These are the kinds of questions that will determine your characters' Physical Lexicon.

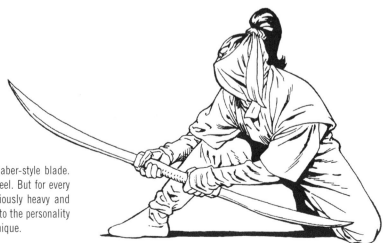

Another modified weapon is this two-handed, double-sided saber-style blade. With this weapon, a character could weave a deadly net of steel. But for every advantage there is usually a drawback. This weapon is obviously heavy and needs both hands to wield it effectively. These limitations add to the personality of the weapon and help make a character's Physical Lexicon unique.

The creation of a character's movement style doesn't only apply to close-range, hand-to-hand techniques and variations on classic martial arts weapons. Once you know how to move a character and a weapon in accordance with his personality, even high-tech and long-range projectile weapons will reveal something about a character.

Just ask the same questions about physicality and personality, and a character's Physical Lexicon will grow from the answers.

For instance, how would a cyborg with a mechanical, bladed hand fight? What sorts of moves might this particular weapon inspire? And what kind of personality might have such a thing in the first place?

Now take a character decked out in full battle armor and loaded with a high-tech laser cannon. Doesn't his choice of armament tell us who he is? Can't we see from his body language what his intentions are? We should be able to discern everything we need to know about a character at a single glance. Even a static figure should reveal something about the character's philosophy of movement.

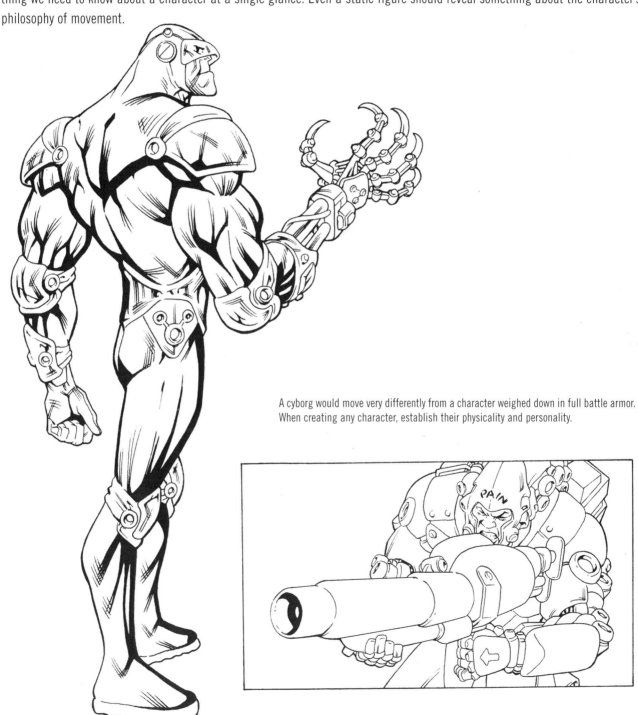

A cyborg would move very differently from a character weighed down in full battle armor. When creating any character, establish their physicality and personality.

Chapter 3

Drawing Figures in Combat

In this chapter we'll learn how to draw characters interacting in combat, how to show the transfer of momentum (from the character throwing a punch to the character receiving the punch), and how to illustrate the effects of physical impact on the human body. We'll also learn how to create a believable superhero punch. To accomplish this, we'll need to add a few more arrows. Now, in addition to the action arrow and the drapery arrow, we'll add the "directional arrow" and the "reaction arrow."

Imagine you are throwing a ball. What path does the ball travel through space? That path is what I refer to as the "directional arrow." The directional arrow will show the speed and direction of the energy expended by the character delivering the strike. Basically, the directional arrow tells us which way and how fast the energy of a strike is moving.

The difference between an action arrow and a directional arrow is that the action arrow describes a character's motion and helps define his shape, while the directional arrow describes how the motion expresses itself outside the character's body. Also in this chapter we will draw the body of the character being struck along the path of the directional arrow.

The reaction arrow will help define the body posture and shape of the impacted figure. Like the action arrow we used in Chapter 1 for the movement of a single character throwing a punch, the reaction arrow influences the graphic design of the character being attacked. (Basically, the reaction arrow is the same as an action arrow, but it describes the movement of the character who is receiving the action.) With the directional arrow illustrating the interaction, the action and reaction arrows can also be thought of as your "cause-and-effect arrows." A punch to the midsection will cause the recipient to double over. Think of the action and reaction as the cause and the effect.

Each of these arrows demonstrates a different aspect of the same movement. By lining up these arrows, you keep the transfer of kinetic energy moving in a consistent and believable manner, which adds to the illusion of actual combat taking place.

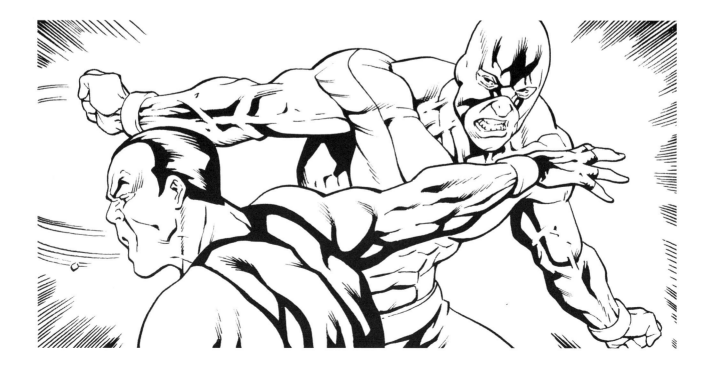

Here's a breakdown of the three distinct arrows.

1 The **action arrow** shows the shape and direction of the attacking character's movement.

2 The **directional arrow** tells us how fast and where the released energy from the attacking figure will go. It also shows the direction in which the character being attacked will go after being struck.

3 The **reaction arrow** helps define the shape and movement of the figure being attacked. It is similar to the action arrow.

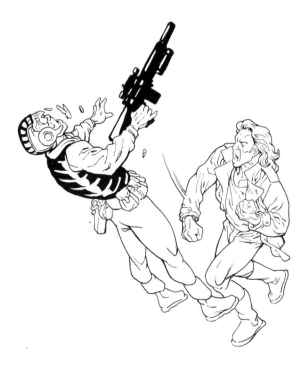

4 Most of the time, all arrows will be invisible in the final drawing. There are a few exceptions that we'll discuss later.

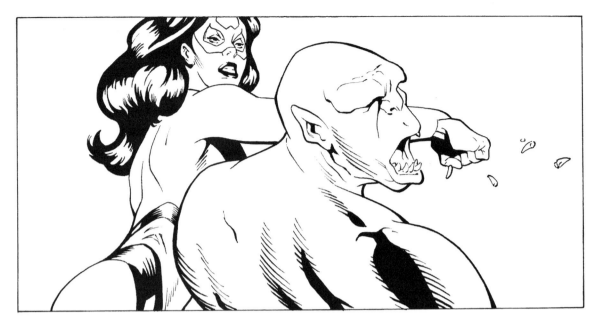

1 Here, the directional arrow shows the path and direction of the strike's energy. You can see the direction in which the impacted figure will move because of that strike.

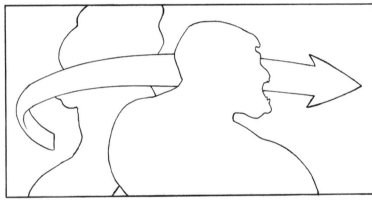

2 It also shows the path of anything carried along by that energy, such as a tooth. Adding these fragments along the line of the directional arrow will add a fourth-dimensional quality to your drawing. The distance traveled by a piece of debris directly correlates to the perceived sense of elapsed time.

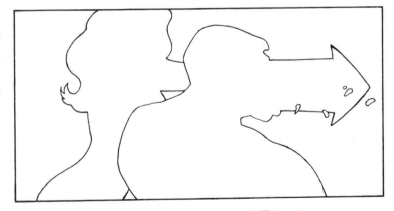

3 The reaction arrow influences the shape of the character that is being attacked. By sharpening or flattening an arrow's point, you can show the intensity of the blow. A short, wide dull point on a reaction arrow is less powerful than a long, sharp point. An elongated point seems inherently faster and more powerful than the other.

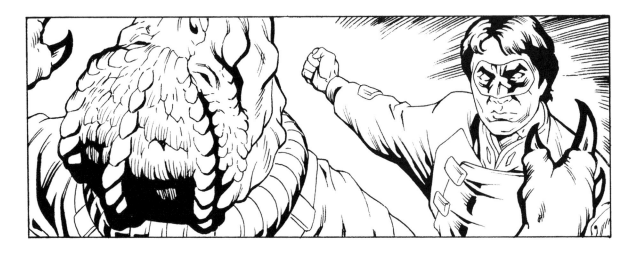

1 Give your character's movements a feeling of completion. Allow them to strike through and beyond their targets. This gives the motion more power and the character a sense of total commitment.

2 The directional arrow begins at the point of contact with the attacking figure's action arrow. It's from that point of contact that the directional and reaction arrows are created.

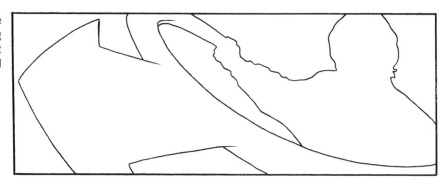

3 Though they describe different aspects of the strike, the directional arrow and the reaction arrow can often be drawn within the same arrow. The arrows are not the same, but in many cases the directional arrow and the reaction arrow overlap.

To recap: The action arrow shows the shape and direction of the character's attack. Placing the figure within the shape of the action arrow helps define the way the figure is drawn.

The directional arrow describes the path of the energy from the strike—it is shown outside of the attacker's body. It is along this path that we place the impacted character. The character's position along the directional arrow will determine the time and distance from the initial point of impact.

The shape of the reaction arrow helps determine the necessary body posture and graphic design of the impacted character.

Often, these arrows overlap and can be displayed as one single arrow. Each of these arrows has a very specific purpose. It's important to think about them separately, but when used together these shapes can give the illusion of seamless interaction.

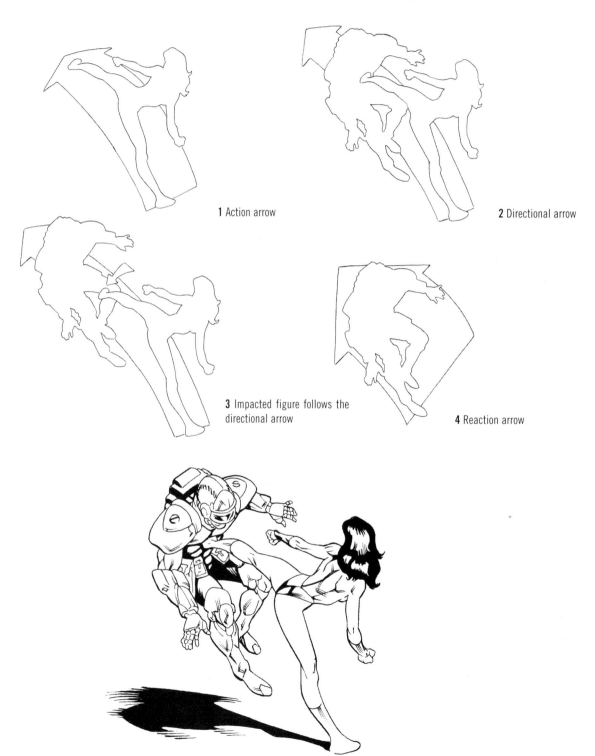

1 Action arrow

2 Directional arrow

3 Impacted figure follows the directional arrow

4 Reaction arrow

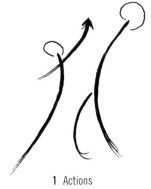

1 Actions

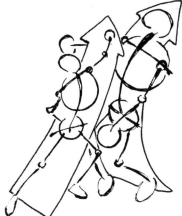

2 Skeletons fit within the expanded action arrows

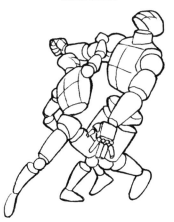

3 Mannequins

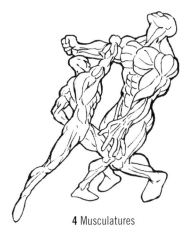

4 Musculatures

Let's practice the use of the arrows by drawing some serious combat. Begin the way you did with your single figure in motion but now draw two action lines to show the initial gestures of both figures. Use the directional arrow to help line up the action arrow and reaction arrows. Then use those arrows to define your stick figures.

Draw your mannequins.

Add the musculature.

Finally, add the details of a finished drawing. Remember to use your drapery arrow to hint at a character's previous position.

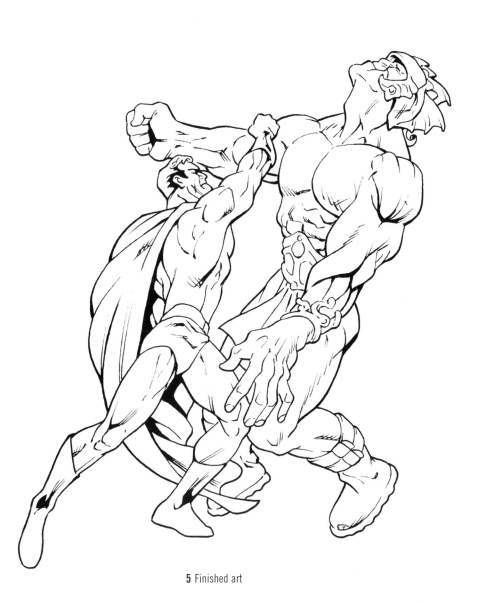

5 Finished art

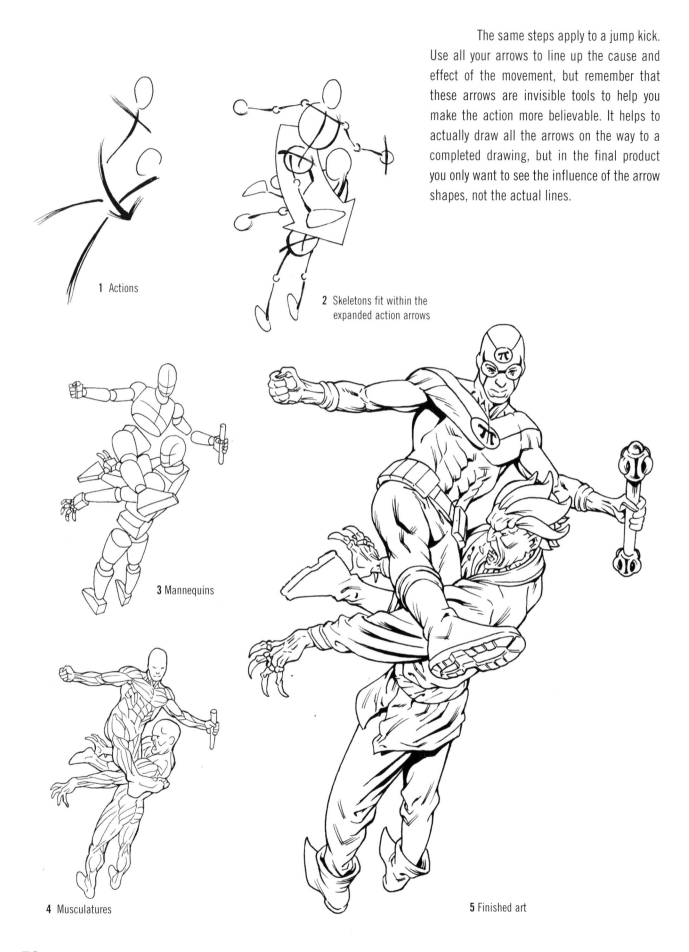

The same steps apply to a jump kick. Use all your arrows to line up the cause and effect of the movement, but remember that these arrows are invisible tools to help you make the action more believable. It helps to actually draw all the arrows on the way to a completed drawing, but in the final product you only want to see the influence of the arrow shapes, not the actual lines.

1 Actions

2 Skeletons fit within the expanded action arrows

3 Mannequins

4 Musculatures

5 Finished art

Even if you have two characters of disparate sizes, the application of these arrows is the same. With thoughtful use of these arrows, you can make any combat move seem real.

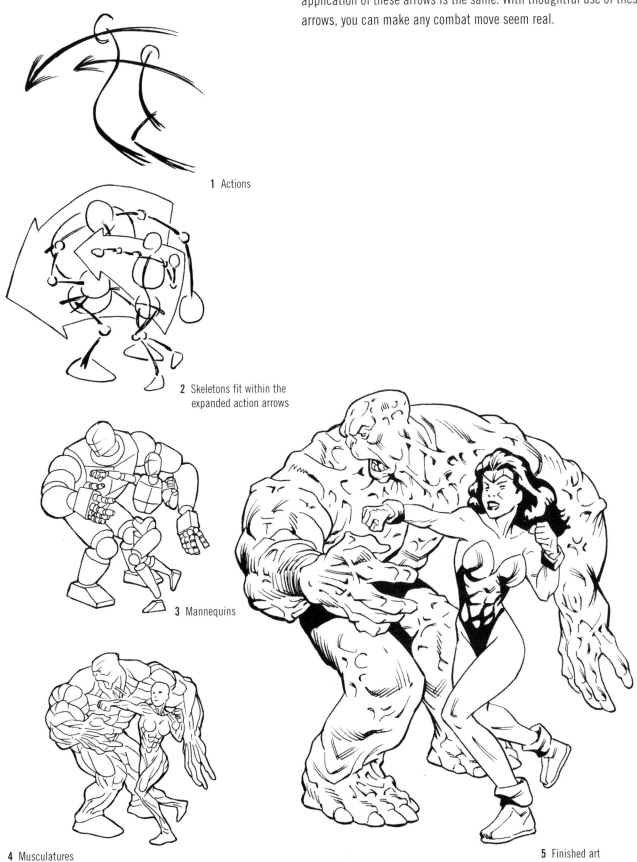

1 Actions

2 Skeletons fit within the expanded action arrows

3 Mannequins

4 Musculatures

5 Finished art

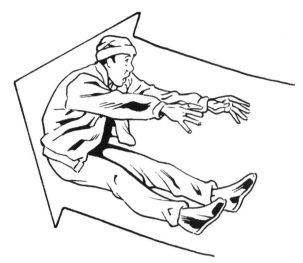

Here are some more examples of directional and reaction arrows. See how they help define the posture and body language of the impacted figure. By fitting the figure within the appropriate arrow, we create a subconscious sense of velocity and trajectory. Drapery should also follow the directional arrow backward through time, aimed at the point of impact.

The shape of the reaction arrow's point determines the bend in the impacted figures body. A sharper point indicates a more powerful impact.

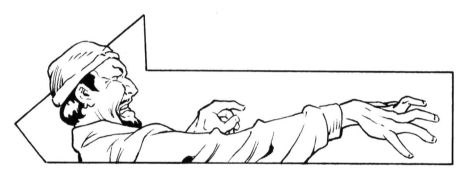

The reaction arrow helps shape even partial figures.

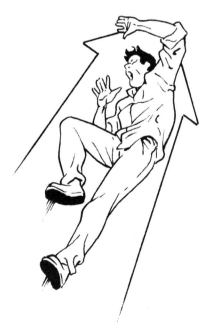

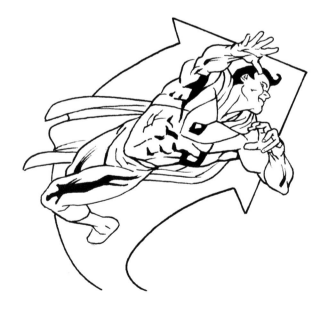

Use the shape of the arrow to draw a foreshortened figure.

Reaction arrows can be curved as well as straight.
Use your drapery to help reinforce the sense of movement.

Visible Arrows: Creating the Illusion of Movement

Up until now the various arrows have been invisible. They have been the underlying structures that shape the final drawing, but for the most part, they have not been seen. Usually, we do not show the lines of the arrows; but sometimes to increase the illusion of movement, we will actually include them.

1 In this drawing, the figure is obviously drawing his sword but could also simply be sitting there with his sword out.

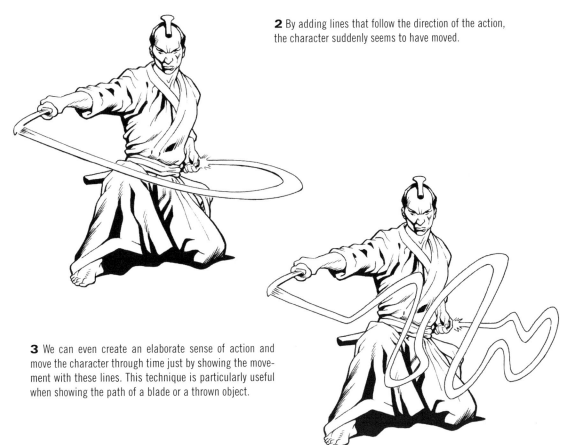

2 By adding lines that follow the direction of the action, the character suddenly seems to have moved.

3 We can even create an elaborate sense of action and move the character through time just by showing the movement with these lines. This technique is particularly useful when showing the path of a blade or a thrown object.

Creating the Illusion of Movement

These lines can also add several moments in time to a drawing by giving the movement an obvious beginning, middle, and end. By showing the lines of the action arrow and directional arrow, we can enhance the feeling of movement through space and time. Drawing the arc of a swinging blade as it cuts through the path of the jumping girl gives the sense that she is narrowly avoiding being sliced in half. This technique is especially useful when interacting characters haven't made contact but you want to show the intersection of their movements.

Enhancing the Illusion

Here are some other ways to enhance the illusion of motion. You can place objects along various paths of direction to help the characters move not only through space but also through time. The dropped gun indicates where the character was a moment before the kick, and his flying teeth give a sense of where he is going (see Figure 1).

Blurring a limb or part of the figure gives the illusion of the figure moving faster than the eye can see. When blurring a limb, add the action lines moving in the same direction as the directional arrow. Drawing lines aimed at the point of impact relates a feeling of energy bursting from the strike (see Figure 2).

When you draw speed lines in the background, they should still follow the flow of the action to enhance the sense of movement in a consistent direction (see Figure 3).

1

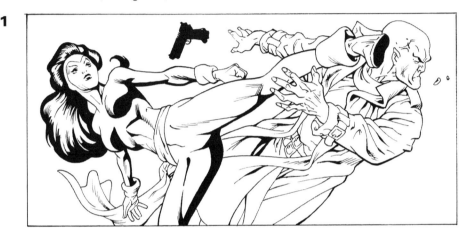

2

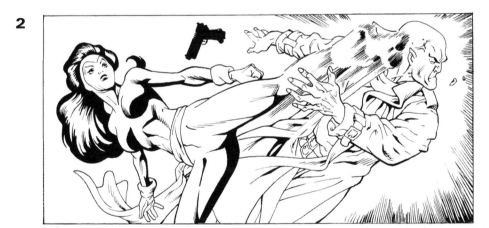

3

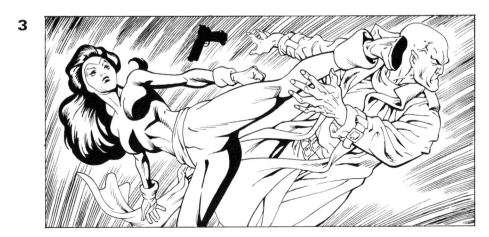

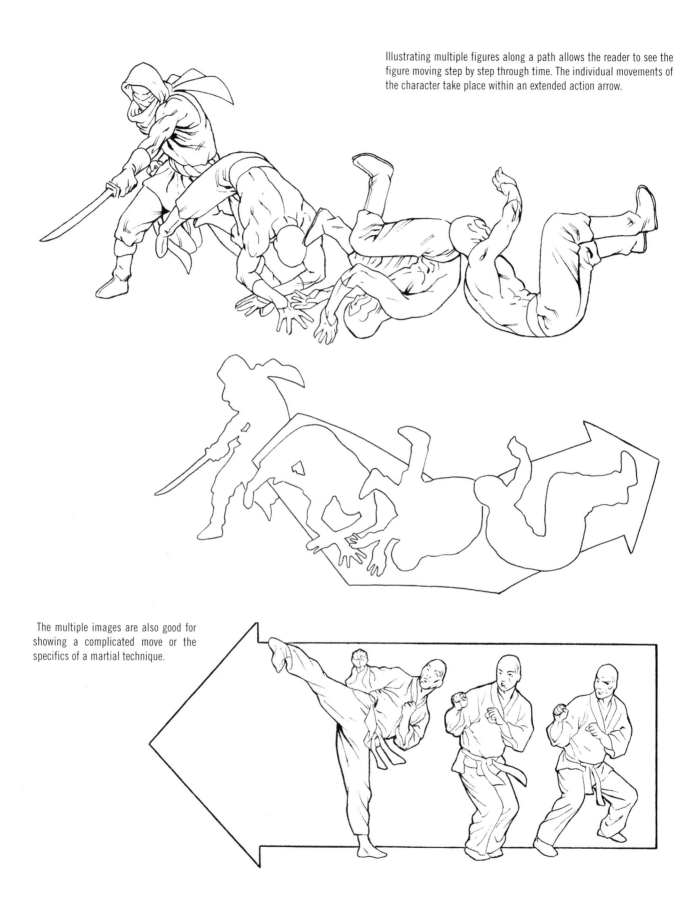

Illustrating multiple figures along a path allows the reader to see the figure moving step by step through time. The individual movements of the character take place within an extended action arrow.

The multiple images are also good for showing a complicated move or the specifics of a martial technique.

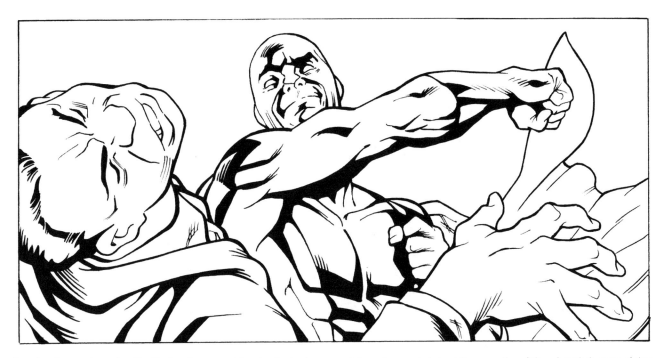

As we've discussed, creating the illusion of movement is not only about movement through space but about the perception of time. A reader's sense of time is greatly defined by how much information there is to interpret.

A single punch with a single element happens fast. An example is this large POW. It reads fast and feels as though it happens fast—the amount of linear information is small and, therefore, is assimilated quickly.

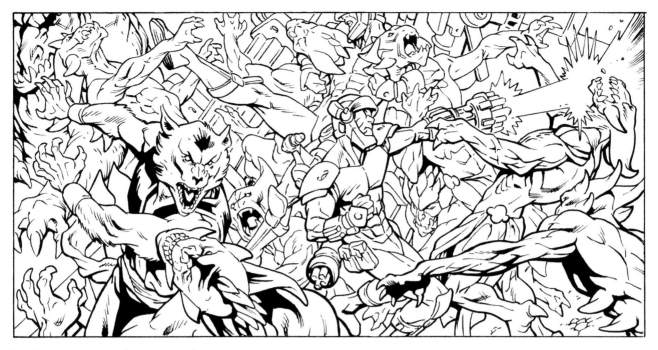

Even though the panel size of this drawing takes up the same physical space as the previous example, the visual information within that space is far denser. It takes the reader much longer to digest.

The sense of elapsed time, therefore, slows down. The linear density of a drawing can greatly influence the perceived motion of time.

Putting It All Together

Now let's put it all together. See how the action arrow, directional arrow, and reaction arrow are all used to determine the shape and posture of the combatant figures? The bursting lines help create the illusion of movement. By controlling the linear density, I've given the drawing a sense of increasing speed across the page.

As an exercise, I want you to use the same background but try drawing these characters in different combat positions. Try to get your characters to move and interact.

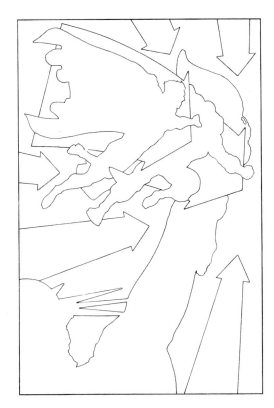

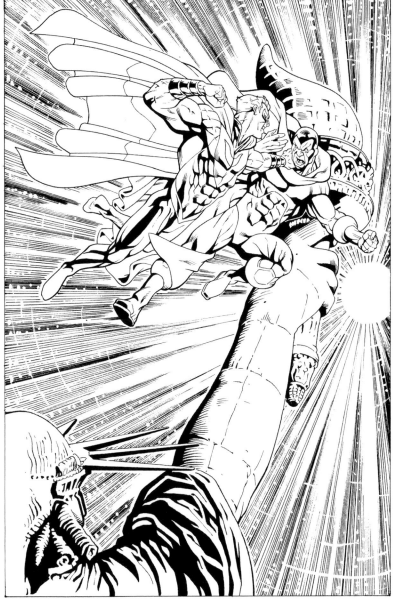

Chapter 4
Drawing Super Powers

Superhumans with incredible powers are the bread and butter of modern action comics. Like the characters from the ancient Greek and Roman myths, the heroes and villains of today's stories are asked to do impossible tasks on a daily basis. When creating a fight scene, you might want to draw any number of unbelievable events—someone turning into a ray of light or picking up and throwing a car. In this chapter we will discuss several ways to make these superpowered actions more credible, and perhaps even natural.

Extraordinary actions performed with ordinary and familiar body movements can lend those actions the credibility of common experience. We have all seen a major-league pitcher throw a fastball, so when that same motion is used to show a character hurl a lightning bolt, it has the flavor of memory and is never questioned.

Wherever possible, illustrate the manifestation of a superpower with a specific visual effect. Your tools may only be little lines on paper, but they can be combined to represent anything you can imagine. With the right linear metaphor, even something as ephemeral as an energy beam will take on weight and solidity.

Show a character's super power by using the character's body and his environment to help tell the story. Tangible and recognizable consequences make even a strange event acceptable.

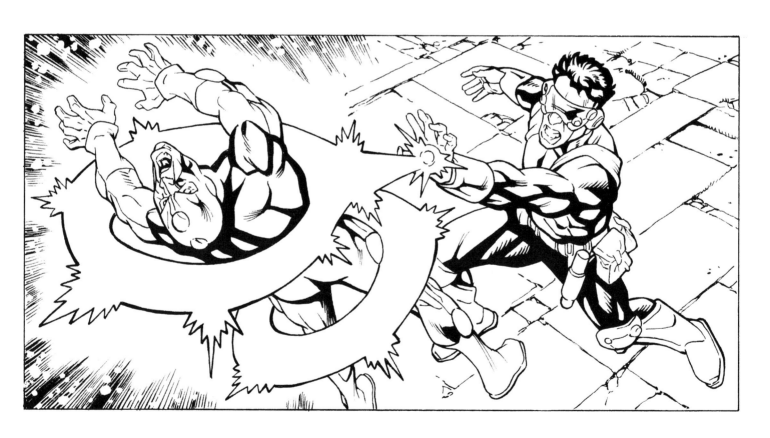

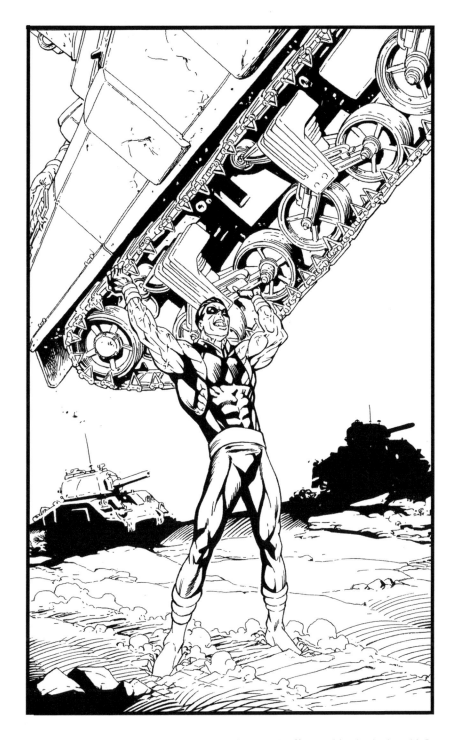

The power of superstrength is best shown through a character's effect on his physical world. Does metal bend in his hand? Can he jump over a building? Can he lift a tank? The idea of strength will mostly be conveyed, not necessarily by how strong the character looks, but by the believability of the weight he is lifting. The drawing doesn't have to be photo-realistic, but it has to have the quality of truth.

Even if a character can lift a tank easily without any apparent strain, the effects of the added weight should be obvious. Notice how the character's feet sink into the ground and how he has to shift his balance to compensate for the vehicle's mass.

If we accept the weight and density of the tank, then it doesn't matter what body type a character has. Once we believe in the tank's reality we will believe in the superstrength of the person lifting it, whether it be a muscle-bound giant, a slender woman, or even a baby.

The power of superspeed is also best illustrated by a character's relationship to his surroundings. We only know how fast a character is moving when we have enough visual information to compare and contrast relative speeds. You must provide the reader with a frame of reference. A character running through a blank white void has no discernible velocity. But that same pose placed in the context of a blurred background gives the impression of superspeed.

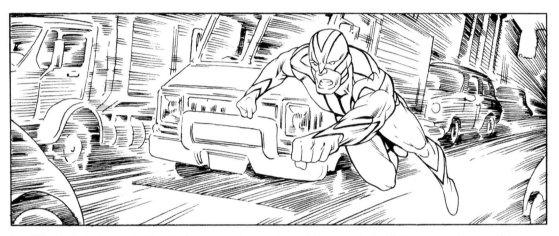

In addition to the technique of either blurring a character or background to communicate relative speed, using a multiple-image shot can stretch the reader's sense of time.

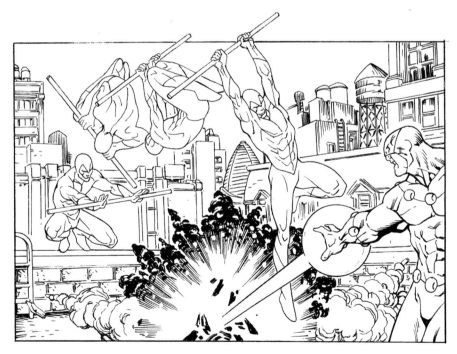

Multiple ghost images of a figure give the impression that the character is making several moves during a single moment.

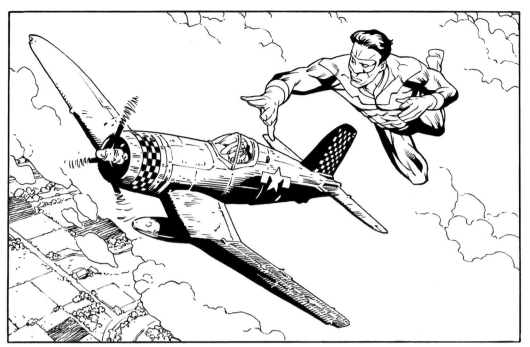

Above and right: When drawing a character in flight, it is important to show positions that suggest flying, and this demands both effort and concentration. But once again, the real trick to making this impossible super power believable is giving it an environmental frame of reference. If the figure is stretched out underwater, then he is swimming. The same body positioned high up in the clouds, looking down at an airplane, tells us that he is flying.

To accentuate the sense of freedom from gravity, point the figure's action arrow in the direction in which a character is flying.

Whenever possible, give the character in flight a dynamic visual effect, such as an aura surrounding the flying figure. Use that effect to reinforce the underlying shape of the action arrow.

Showing Energy

There are as many different kinds of energy powers as there are different wavelengths of radiation along the electromagnetic spectrum, from low-energy radio waves to high-intensity gamma waves. When illustrating these, use a different kind of line to describe a different wavelength of energy. Try to match the type of line to the specific nature of the energy. You can represent heat with a wavy line, electricity with a jagged lightning bolt, solid light with thick black holding lines.

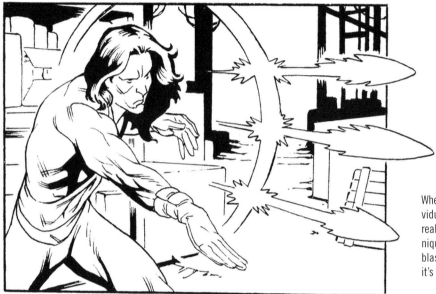

Whether the energy is a continuous solid ray or individual energy bolts, draw them as though they are real. Give them weight and volume. A useful technique to show the three-dimensionality of an energy blast is to have it go beyond the panel—as though it's shooting right off the page.

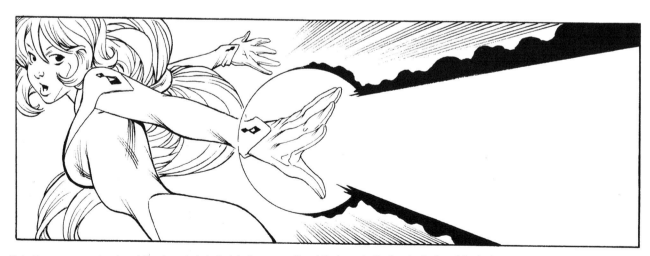

Make the energy an extension of the character's body. Join the perspective of the beam to the foreshortening of the body.

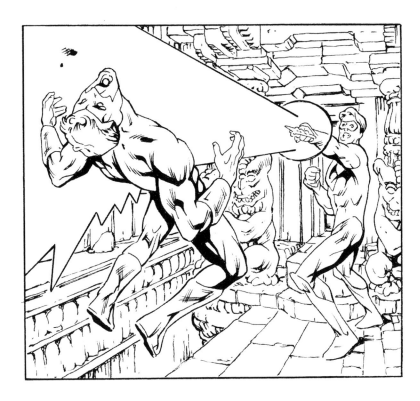

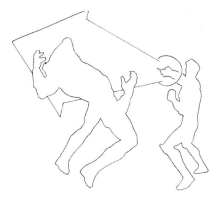

Left and above: An energy beam has to be solid and have the same kinetic impact as a physical blow. The character shooting the energy beam should have a body movement that is similar to punching, throwing, or pushing.

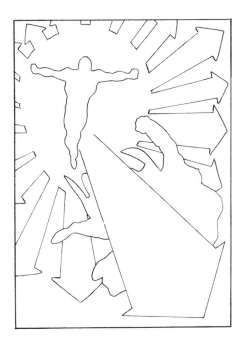

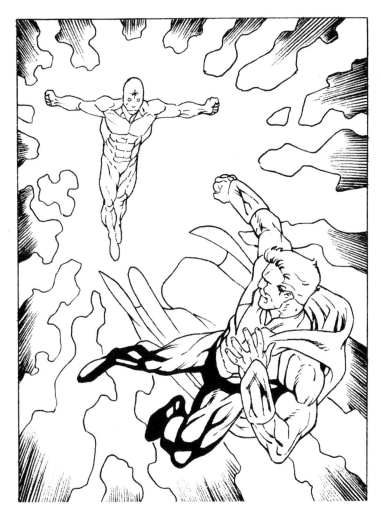

Above and right: In the case of a radiant energy blast, all directions should have the same effect as a single energy blast. All the same theories of drawing a believable character in combat apply to using an energy blast as a weapon. The reactions of the impacted figure will still be defined by the various arrows.

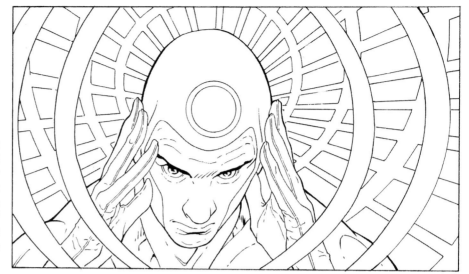

The same general rules for drawing energy powers also apply to illustrating mental powers. By creating a special effect or visual metaphor for something that can't be seen, we can give physical weight to an invisible power. Whatever combination of lines you use to represent a superpower is completely up to you, but it should invoke the nature of the power.

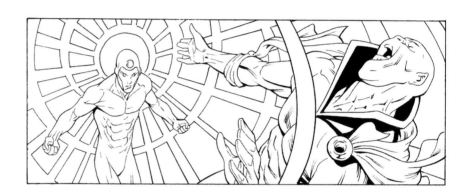

In this case, I pictured the character's telepathic ability as a solid web of thought. But it's the body posture and the facial expression that really emphasize the event.

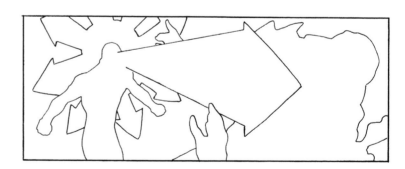

The drapery arrows are blown back, away from the attack. This reinforces the solidity of the attack.

Even though the power is non-physical it still moves the impacted character the way a punch or a kick would, so a reaction arrow helps to shape the figure.

Making Super Power Seem Real

Lastly, the easiest way to make a super power real for the reader is to make it real for your characters. Show just how much effort is being expended by using those powers.

Add facial expressions and appropriate body language: gritted teeth, clenched fists, a scream, bugged eyes, etc. It's more believable when outrageous powers have realistic body movements.

When your characters are doing something outside the reader's normal frame of reference, you must give your drawing an extra dose of verisimilitude. By paying careful attention to the details, you can suspend the reader's inherent disbelief and make him or her accept the impossible.

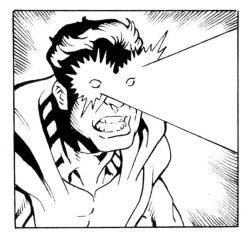

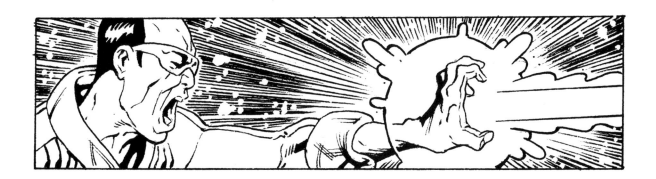

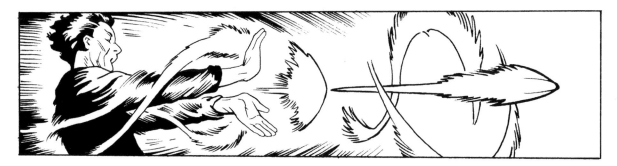

Facial expressions and appropriate body language aid in the illusion of super powers.

Chapter 5
Creating Environments

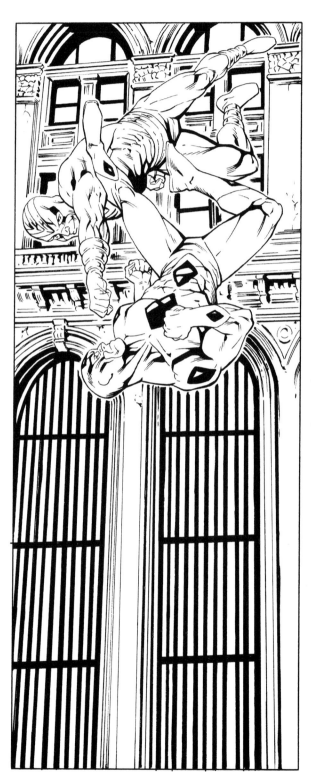

Think of the environment, or setting of the fight scene, as an active participant in the confrontation between your characters. While it doesn't choose sides, it will have a definite effect on the conflict's outcome.

The background must communicate much more than just the location of the fight. The elements and design of the environment should reflect the nature of the conflict and reinforce the important narrative themes. For instance, if one character is a robot and the other is a plant creature, where they fight—jungle or science lab—automatically influences the power dynamic.

A recognizable or familiar setting can also help create an emotional connection with the reader. A battle taking place at the top of the Statue of Liberty is already more engaging because it is set in a shared frame of reference.

Many of the skills you have learned for drawing the figure apply to drawing an environment. The basics of putting together three-dimensional shapes in perspective have already been well practiced. They will now be applied to a place instead of to a person. When creating backgrounds, it is important that you remember the needs of your characters. Who are they, and what are they fighting for? Once you answer these questions, the environments will grow naturally.

By combining your basic shapes, you can create anything, from a simple chair to something as complex as an armored battle vehicle. In fact, creating the environments and props in your characters' world is much easier than creating the characters themselves. The biggest challenge is learning how things fit together. Study life and pull from your own experiences. You have a tremendous amount of visual information in your head. Allow yourself to access the knowledge and you will be amazed at what you can draw.

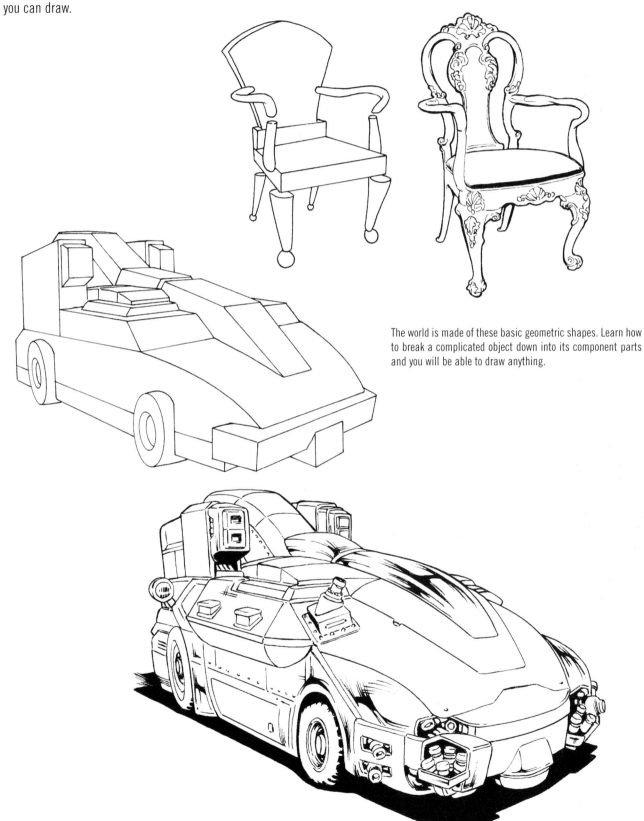

The world is made of these basic geometric shapes. Learn how to break a complicated object down into its component parts and you will be able to draw anything.

The Basic Steps

Before putting pencil to paper it is important to get a basic mental image of the intended environment. It doesn't have to be a perfect picture, just get an idea of the general shape of the space and what kinds of objects will fill it.

When drawing an environment, it is important to put in the appropriate details. It needs to be a believable place. If you're drawing an alleyway, make sure that the garbage and debris are smelly and disgusting. However, if you're drawing a crashed spaceship, make sure that the debris is high-tech and mysterious.

Step 1: Creating an environment is basically the same as creating a figure. You will once again draw a skeleton, but instead of the skeleton representing the actual bones of a body, the skeleton of your environment is your horizon line and your lines of perspective.

Step 2: Add basic shapes along the lines of perspective. Remember, you want this environment to be interesting and possibly even dangerous, so give it many levels and different shapes.

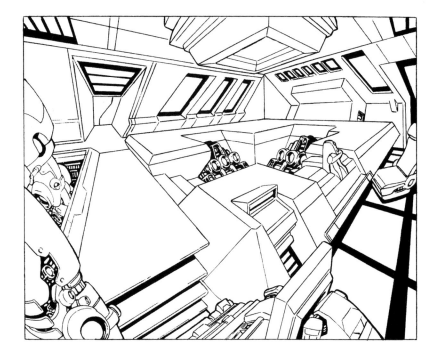

Step 3: The finished drawing. Here we have a high-tech lab, replete with many scientific gadgets and gizmos.

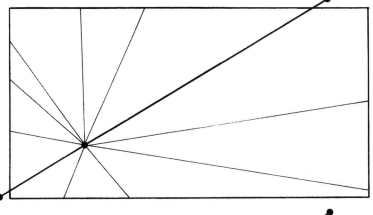

Step 1: Once again, start with your horizon line and perspective lines.

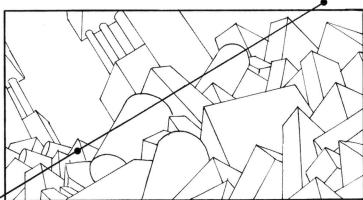

Step 2: Add your three-dimensional shapes along those lines of perspective.

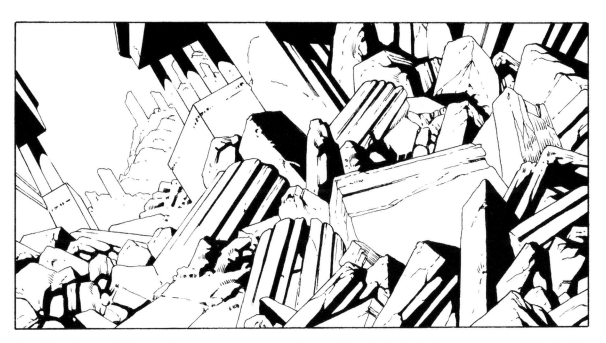

Step 3: Throw in some light and shadow, and now you have a ruined temple. By angling the horizon line, we change our relationship to the characters within the panel and add tension to the drawing because we feel off-balance. Is your environment a contemporary citiscape or a futuristic world? In any case, be certain to draw appropriate details.

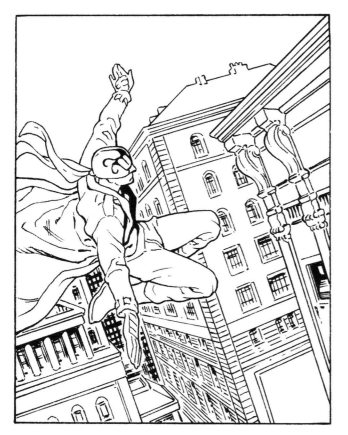

Even though a battle will take place within the borders of your panel, it is important to hint at the world beyond the panel's window. You have to create the sense that more of the environment exists than we get to see. Provide enough information to allow the reader's mind to complete the picture. If a character jumps past the reader's point of view or is thrown out of the panel, the reader must automatically picture where he will land.

We discussed this concept of helping the reader create his or her own mental images in Chapter 1. I referred to it as the fifth-dimensional quality of a drawing. Now you see that it applies to more than just your figure work. It is this phenomenon that allows static images to move and to fight. It is this interaction between the art and the viewer that will bring your stories to life.

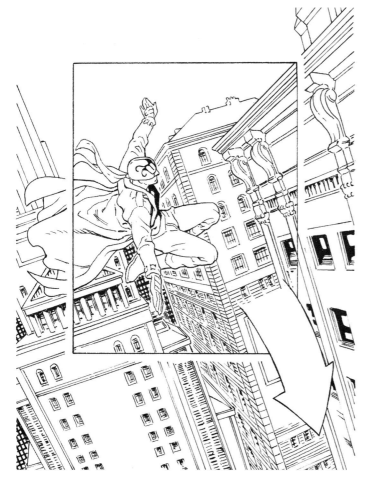

The reality of your environment must extend beyond the borders of your panel.

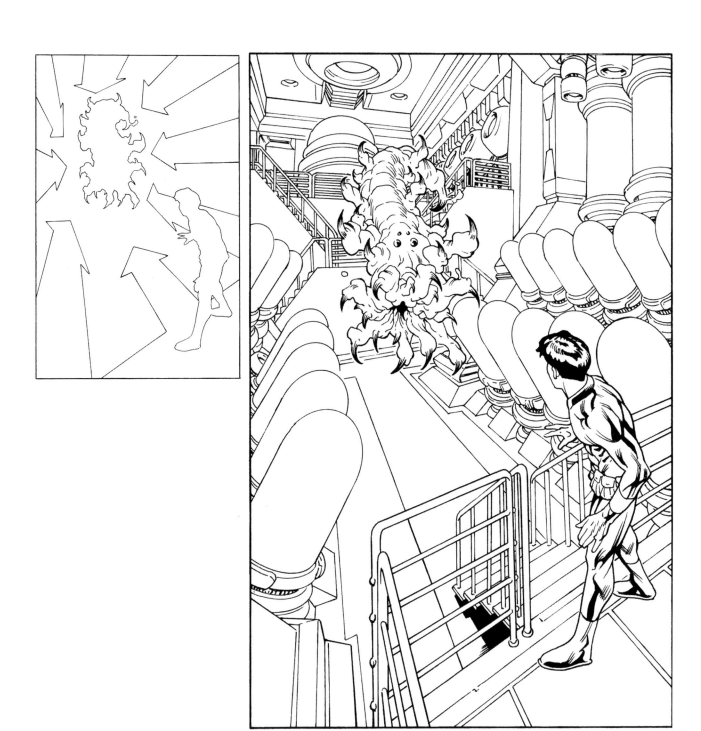

Create a focal point in the panel by using the shapes and elements of the environment to direct the eye of the reader. By using the background to guide the reader's focus, you can create an emotional relationship between the characters and the reader. It shows the reader who to root for and where the danger is.

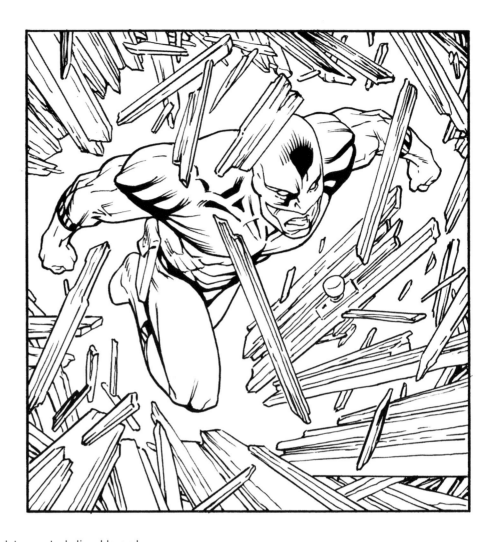

Now that you've learned to create believable and interesting environments, you can get into the serious business of destroying them. It's called collateral damage—and it is inevitable when two supercharacters throw down! Walls will crumble, glass will shatter, and someone might get hit by a truck. When drawing a destroyed environment, it is important to know how different materials break. Wood splinters, concrete breaks off in chunks, and engines fly into pieces. Destroying something is easy: just remember to use your directional arrows. For instance, when someone comes bursting through a door, the directional arrows will radiate from the point of contact. You already understand how to illustrate the transfer of energy and momentum; all you have to do now is apply that understanding to different types of debris.

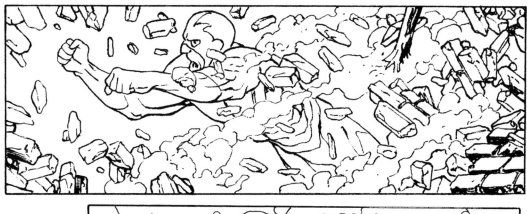

When destroying brick or concrete, it is important to remember that pieces of bricks, whole bricks, and concrete dust follow along the direction of the character's initial action arrow. Some chunks may fly off in different angles from the point of impact, but the majority of the dusty debris will follow in the wake of the passing character. This dust serves the same purpose and function as drapery in showing fourth-dimensional movement.

When shattered, glass will radiate out in all directions away from the point of impact. Having some shards fly directly toward the reader will enhance the sense of danger. There will be a number of directional arrows moving in different directions.

Different materials will break down into distinctly different basic geometric shapes. Glass can be represented by triangles, wood by trapezoids, and bricks by squares and rectangles. Experiment with different shapes and see what inherent qualities they seem to possess.

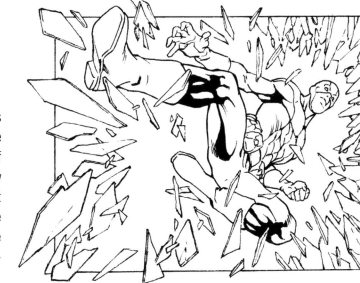

Final Exercise

Now let's put all the lessons together into a single drawing. Here we have several different kinds of debris. See how the dust shows in what direction the bricks are falling and even hints at how fast they may be moving? Small pieces of glass and concrete follow the same directional arrows, illustrating a common point of origin. The building extends past the panel borders, which gives the drawing a more intense feeling of weight. Lines of debris in the background all point toward our hero, drawing our reader right into the focus of the action. The ground beneath his feet is cracked, showing the heavy load crashing onto his shoulders.

As your final exercise in this chapter, I want you to deconstruct this drawing down to its most basic elements. Take it all the way back to the skeleton stage. Notice how the figure's action arrow lines up with the direction of the final debris. See how the simple shapes of cylinders and cubes can combine to create a believable reality?

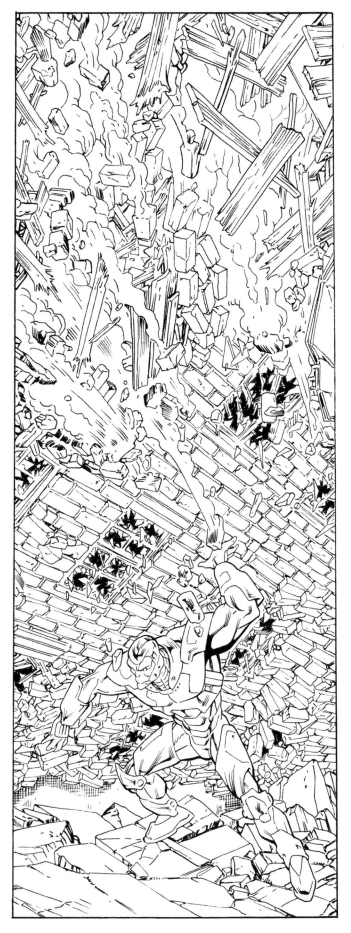

Chapter 6
Defining Your Characters

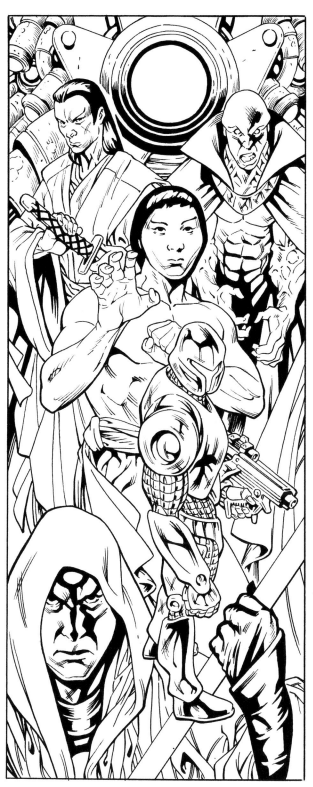

Now it's time to apply everything you've learned to create your own characters. Think about what kind of characters you want them to be and what role they will play in the story. Will they be heroes or villains? Will they be a lone character or a member of an extended cast? What kind of powers do they have, and how will those powers manifest? How will they deal with confrontation?

Use what you know about basic shapes and body types to create a body that will fit the personality and disposition of your character. Pick a style of movement that further explains who this person is and what his agenda might be. Create a Physical Lexicon based on that style of movement, his body type, his philosophical relationship to violence, and any superpowers he might possess. Give your characters individual histories and motivations.

Once you know who a character is and how he moves then you know how he will handle himself in a fight. When a character moves in accordance with his inherent philosophy, then the fight scene can be more than just two characters hitting each other. It can be a metaphor for the battles between ideas.

Dark Cabal

Here we have the Dark Cabal. He's a villain, and he enjoys murder. His style of movement is violent and very cruel. He is skilled in many martial arts and is proficient in the use of all weapons, from the long curved blade of Silat to the most high-tech firearms. His superpower is the ability to steal your soul, which he does by grabbing it and yanking it straight out of your body. Once a soul is taken, all the abilities and knowledge of the victim are then his to use. With the talents he's gained through his power, his Physical Lexicon of techniques is broad and varied—but his personality shows in every move.

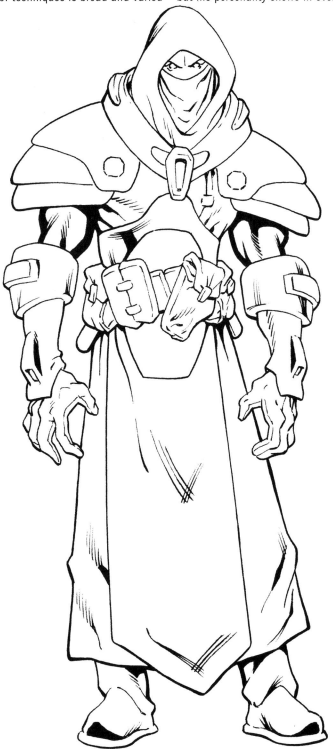

Even though he has a huge library of potential techniques, he will always pick the most vicious response to any attack. He will not refrain from eye gouging, fish hooking, or strikes to the groin. The potential strike zones on an opponent cover the entire body, including many spots that will cripple and kill.

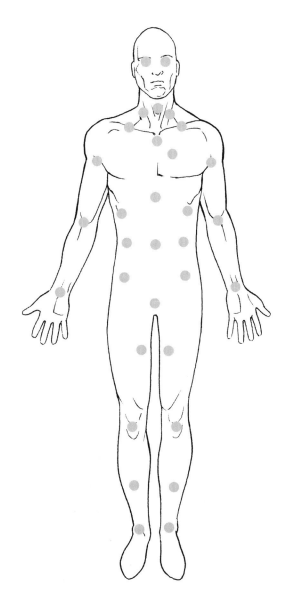

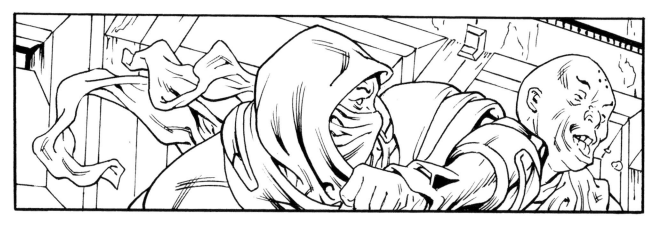

Here are a few examples from his Physical Lexicon of fighting moves: The Muay Thai elbow strike to the temple, which can shatter the temporal bone of the skull, causing pieces of bone to tear into the brain. This technique has been banned from use in competitive Muay Thai matches and is, of course, one of Dark Cabal's favorite moves.

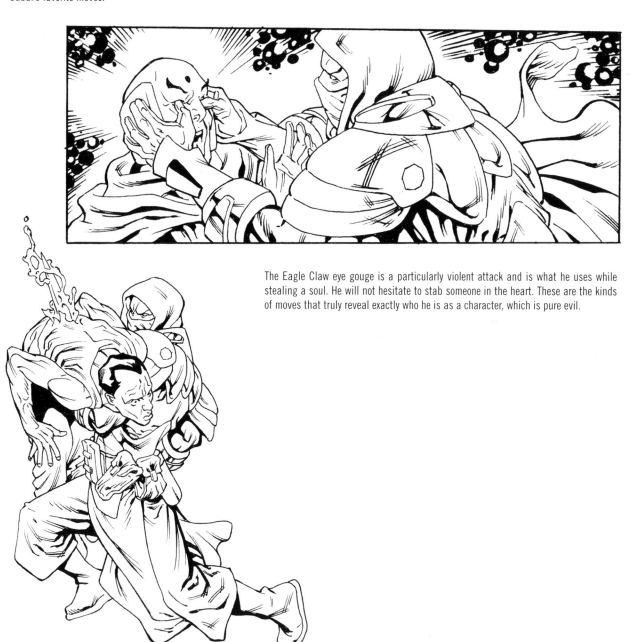

The Eagle Claw eye gouge is a particularly violent attack and is what he uses while stealing a soul. He will not hesitate to stab someone in the heart. These are the kinds of moves that truly reveal exactly who he is as a character, which is pure evil.

Naginata Tenchu

This is Naginata Tenchu. She carries the Spear of Heaven's Punishment. She is fast and agile, and her movements are graceful and beautiful. Even though she uses the bladed staff as her primary weapon, she has a code against killing and will never use the naginata to take a life. Her form is always perfect, and her techniques are very specific. She has no special powers, but she is so highly trained that her acrobatic and martial skills are practically superhuman.

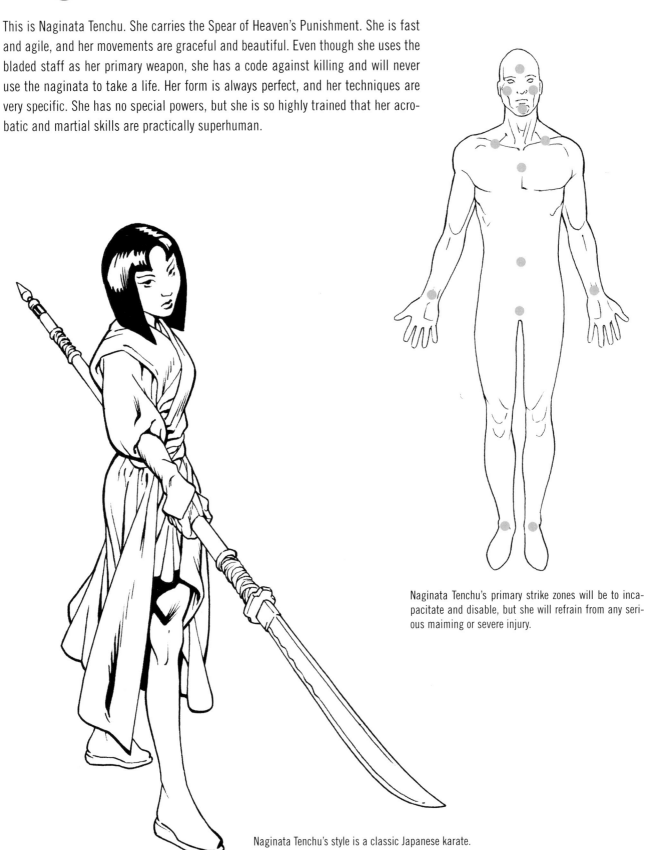

Naginata Tenchu's primary strike zones will be to incapacitate and disable, but she will refrain from any serious maiming or severe injury.

Naginata Tenchu's style is a classic Japanese karate.

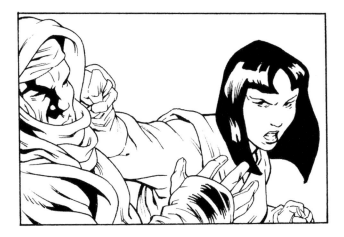

Even though Naginata Tenchu is capable of elaborate and flashy combinations, she tends to favor the more classic karate moves.

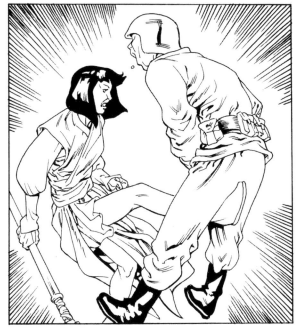

Her personality is honorable and direct, and those traits manifest themselves in her choice of technique, such as gyaku-zuki, the straight reverse punch, or maigeri, the front kick.

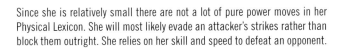

Since she is relatively small there are not a lot of pure power moves in her Physical Lexicon. She will most likely evade an attacker's strikes rather than block them outright. She relies on her skill and speed to defeat an opponent.

Private Impasse

This is Private Impasse. This character is superstrong and practically invulnerable. He can crush stone with his bare hands and is impervious to most attacks. Even bullets bounce right off him. He has no precision strikes.

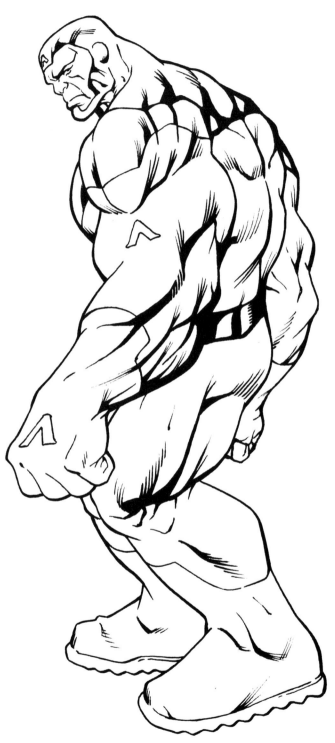

Private Impasse's target zones are simply center mass. He will hit you in the head, or he will hit you in the body—he won't give it much more thought than that.

Private Impasse's Physical Lexicon shows that he doesn't need many martial skills. In his case, the absence of technique helps define his personality and character.

Since fancy technique is not his strong suit, his moves are limited to something such as a roundhouse punch or a back-fist. Using his power, he may strike the ground and cause a shock wave.

It's important to know what your character can and cannot do while choreographing a fight scene. The physical moves must be appropriate to the body type. An inappropriate move will destroy the suspension of disbelief.

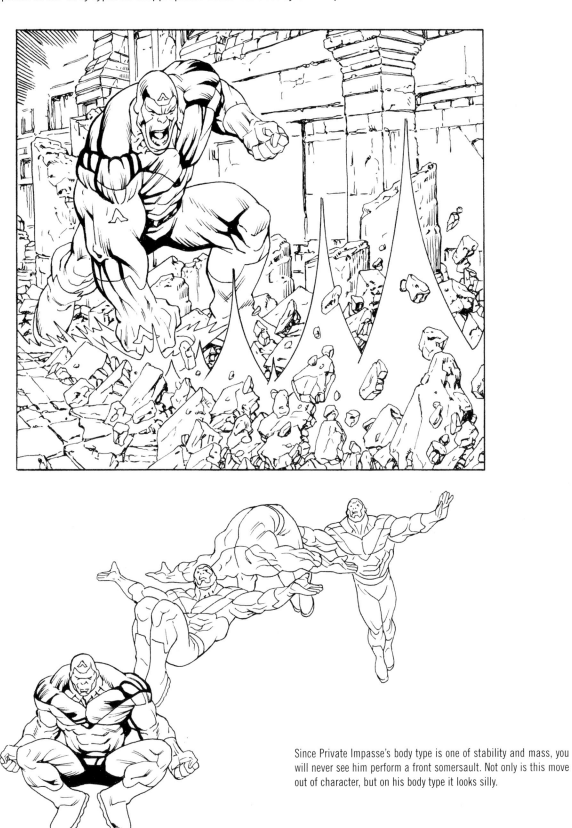

Since Private Impasse's body type is one of stability and mass, you will never see him perform a front somersault. Not only is this move out of character, but on his body type it looks silly.

Final Exercise

Here are a couple of different body types. Your final exercise for this chapter is to add the details to the costume, create superpowers, and catalog a list of appropriate combat moves based on that character's personality and disposition.

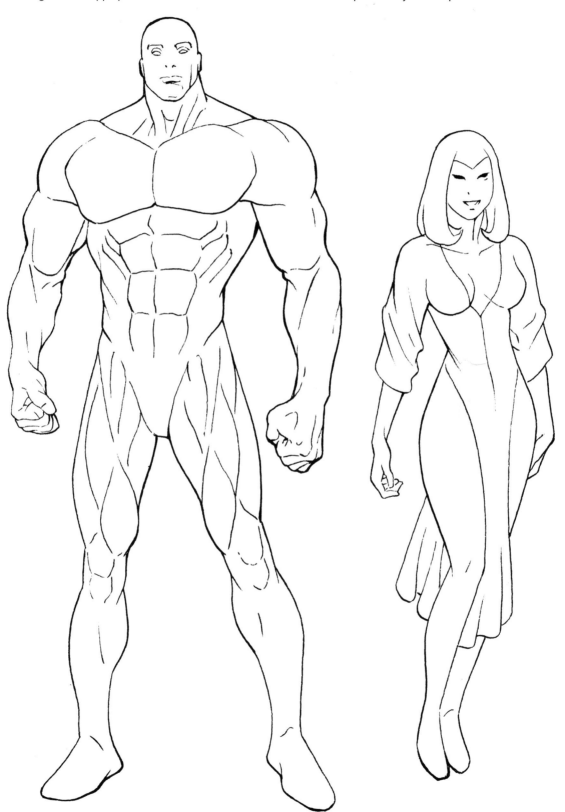

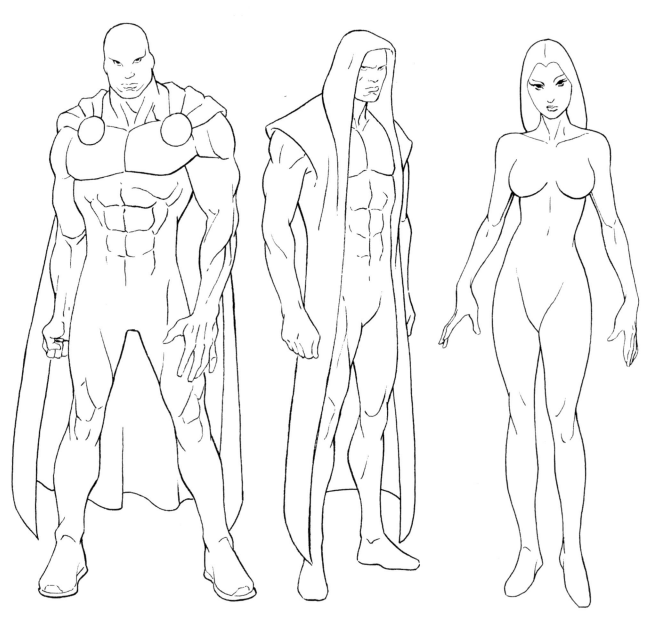

See how different moves seem appropriate to different body types? See how different personalities move the same body type in completely different ways? It is the interaction between personality and physicality that determines the character's Physical Lexicon.

Keep in mind what kind of outfits or clothing your characters might wear and how that might affect the look and feel of their movements. Once again, it is important to be appropriate. Someone with heavy armor will not be flipping around or jumping easily through the air.

Chapter 7
Stages of a Fight Scene

For the purposes of clear storytelling, I have broken down the fight scene into five distinct stages, as shown below.

As a tool to help move the reader through these stages, I'm going to introduce one final arrow, the "intention arrow." This is not an arrow that will be seen in any final drawing, but it is paramount to our understanding of the fight scene. The intention arrow will almost always follow a character's action arrow, but even a character who is standing still may have a plan or a goal, which can be illustrated as an intended direction.

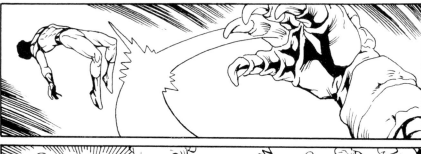

Stage 1: Establishing the Relationship

Stage 2: The Initial Attack

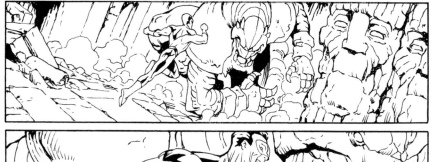

Stage 3: The Reversal

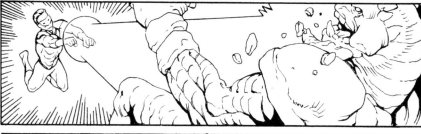

Stage 4: The Final Attack

Stage 5: Establishing the New Relationship

The intention arrow shows us where a character is looking and where he intends to go. It's that simple. Since the reader looks where the character looks and goes whereever the characters goes, the intention arrow is what actually moves the reader through the narrative of the story.

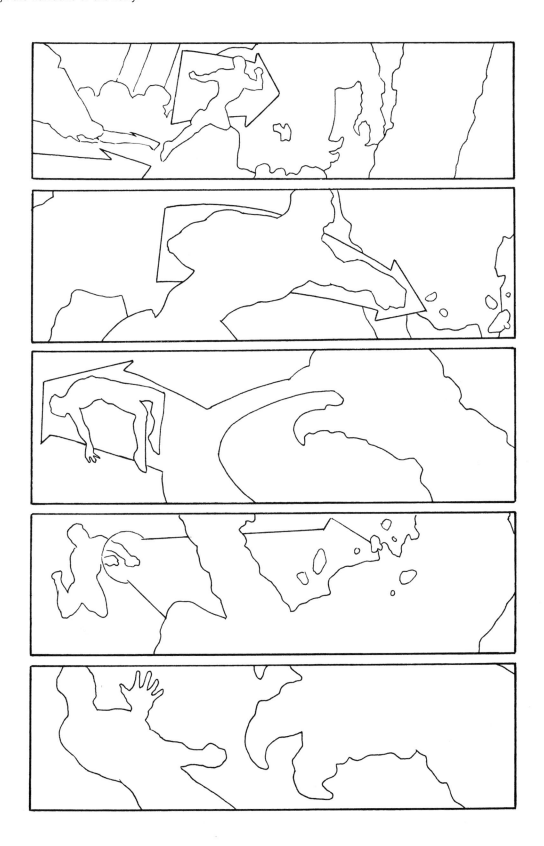

Establishing the Relationship

In this first stage, we need to see a clear relationship between all the characters involved in the conflict. The first stage of every fight scene must show who is fighting and where they're fighting, and give an inkling of why they're fighting. The spatial relationship between the combatants, the potential advantages and dangers of the environment, and the emotional relationship between the combatants and the reader should all be communicated in this stage of the fight scene.

See how the intention arrows of each combatant are clearly defined by their body posture and expressions? The characters' goals and relationship are obvious.

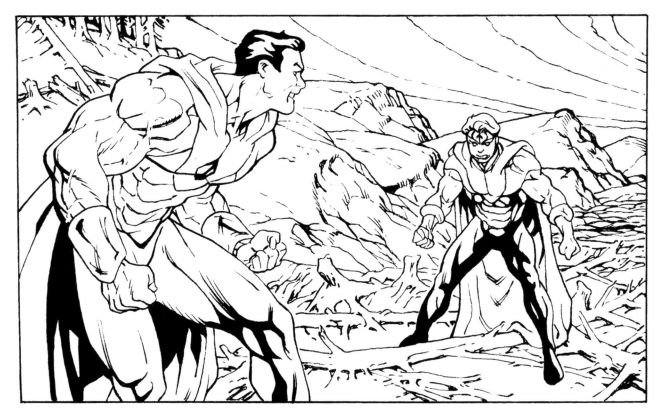

As I mentioned earlier, establishing a relationship not only refers to the relationship between the combatants but also the relationship of those combatants to the reader. It is in this first stage that we develop an emotional connection to the characters.

In the two top panels, we see that there are two people in conflict. One has a sword pointing at the other one; we see that they have intention toward each other, yet we don't quite know what's happening or why, and as readers, we don't really care.

In the two bottom panels, we see that by adding the reader's perspective to the scene, we have actually placed him or her in danger along with the protagonist. We have forced the reader to choose a side.

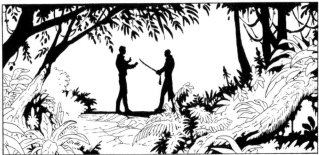

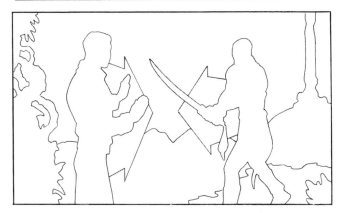

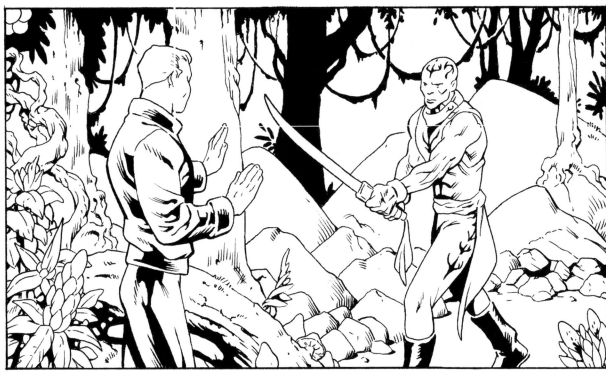

Look at a scene from different angles—similar to how you would use a camera. This will help you create dynamic compositions. The angle you choose for a scene greatly influences the relationship of the reader to the characters in the story. Think of your reader as not just watching the action, but participating in the drama. Imagine that you are moving a camera around the scene and see how different points of view affect your emotional response. Compose the panel in a way to best illustrate the important elements of the conflict.

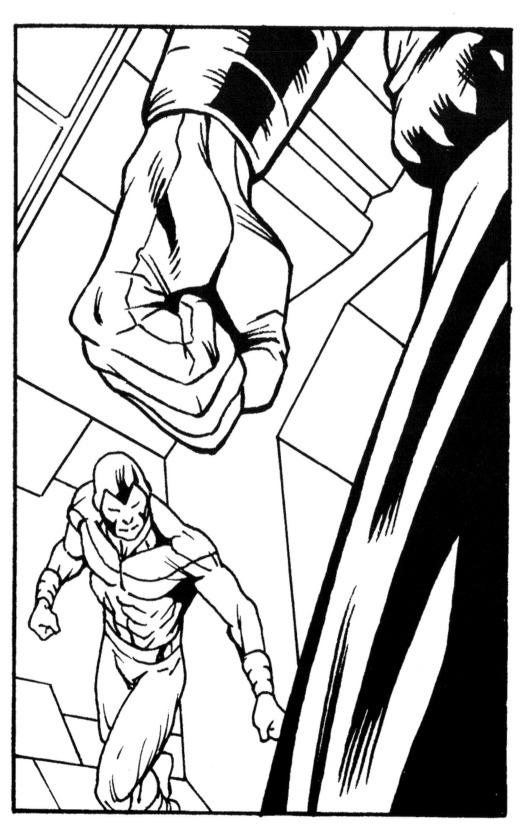

With our relationship to the characters and the nature of their conflict clearly defined, the next step is to establish their relationship to the environment. As we discussed in Chapter 5, the environment will help decide the outcome of the conflict and will probably play a major part in the specifics of the battle. Does the environment give one character an advantage over the other? Are the characters in danger from the environment itself? How does the environment relate to the greater story line?

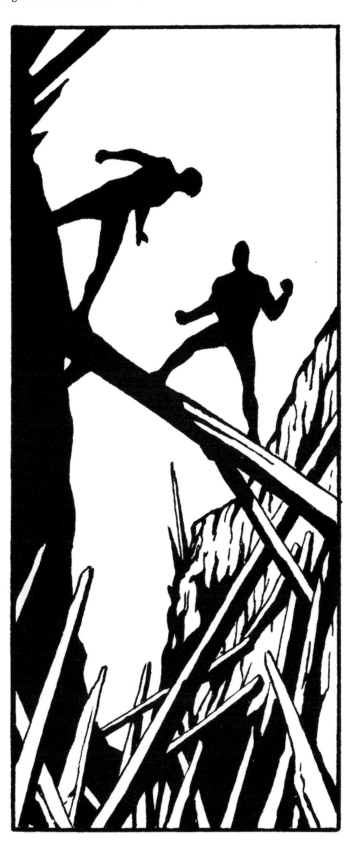

This one panel tells the whole story at a glance. We see the fundamental nature of the conflict and understand the danger. We are emotionally involved, and we see how the various elements of the environment may influence the upcoming battle.

As an exercise, I want you to draw this scene from a few different angles. What would the point of view look like from behind the dragon or right next to our ax-wielding barbarian friend? See how a different perspective can change the reader's emotional allegiance?

JOHNSON-PANOSIAN

The Initial Attack

This is the first strike. It can be a single blow or a series of uninterrupted attacks. The initial attack reveals much about the nature of the combatants: Who is the aggressor? Who has the strongest position and the greatest potential for victory? A character that attacks first tells you something about his relationship to violence. When a character chooses to engage in conflict says as much about him as how he handles himself during that conflict.

 The initial attack can take the form of any obvious aggression, whether it be an energy blast, a slap, a jump kick, or even a verbal threat. The initial attack is defined by the consistent direction of the attacker's action arrow. If the first attack is moving from the left to the right, then the flow of the action will continue moving in a line that is consistent with that direction.

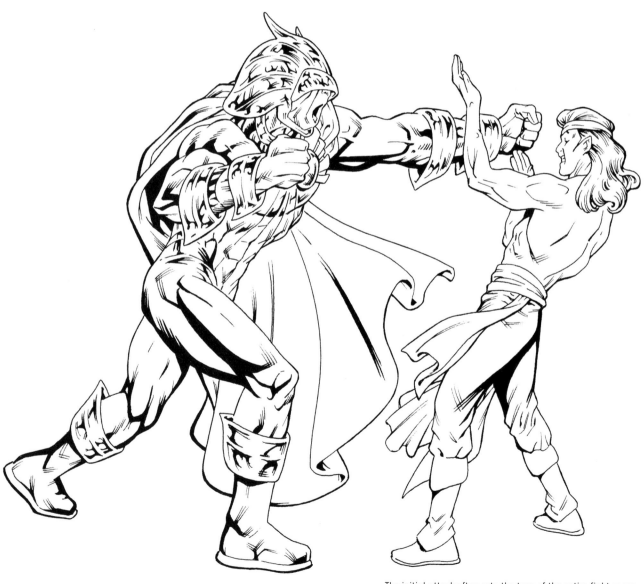

The initial attack often sets the tone of the entire fight scene.

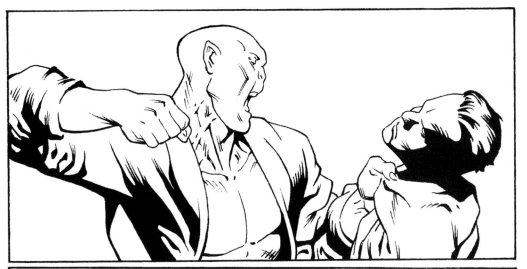

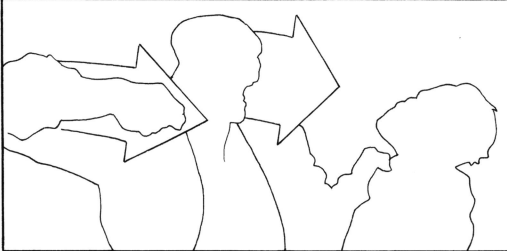

The intention arrows of the attacking character continue in a consistent direction during the initial attack stage.

REMEMBER, WORDS CAN HURT. ESPECIALLY WHEN THEY ARE OUT OF A MOUTH LIKE MINE.

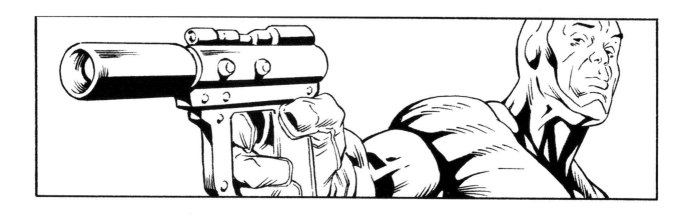

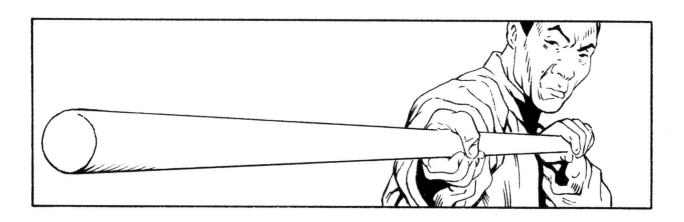

Share the sense of danger. Whether it's a gun, a staff, or a fist, point the weapon at the camera and give the reader the feeling of being attacked.

The Reversal

When the recipient of the initial attack strikes back or turns the tide of battle, this is what I refer to as a "reversal." It is when the action arrow turns and points the other way. There can be an endless number of reversals in this stage. This is where the meat of the fight scene will take place. As characters strive to defeat each other, the action will flow back and forth.

Here the attack is coming in from the right side of the panel and the action is moving from right to left. The reader automatically follows the intention of the attacker towards our hero.

Our hero responds to the attack and now the action is moving from left to right. This reversal of movement not only changes the relationship between the combatants but it shifts the reader's perception of which character is now in control.

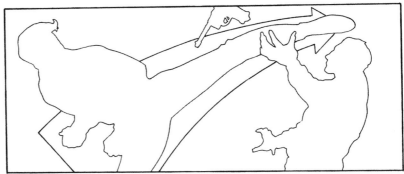

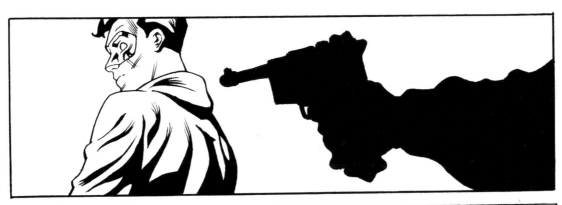

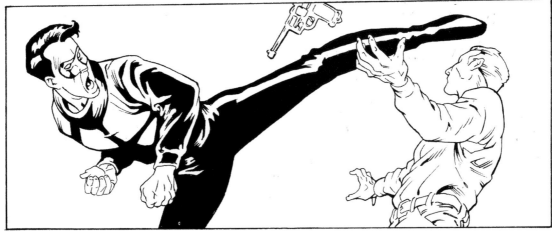

A classic and dramatic reversal is when all hope seems to be lost and the character snatches victory from the jaws of defeat. In narrative terms this is known as "The Dark Moment." Think of the fight scene in terms of the character's personal story arc. The individual moments of the fight scene are just visual metaphors for the character's journey through the larger narrative. Thinking of the action in these terms gives greater meaning to every block and punch thrown.

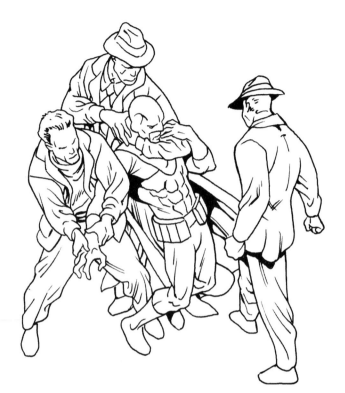

Left: The intention arrows and action arrows of the attackers are aimed inward toward our hero. He is clearly in trouble.

Below: Now the reaction arrows are all pointing outward away from our hero. A reversal of the action has taken place. Our hero has taken control and is on top of the action.

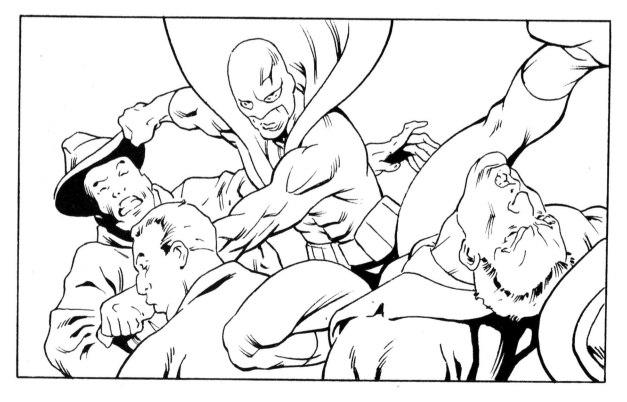

The Final Attack

This is the end of the battle. Whether it is a single blow or a devastating series of moves, there will be no more reversals. From the beginning of the final attack to the end of this particular stage, the action only flows in one direction.

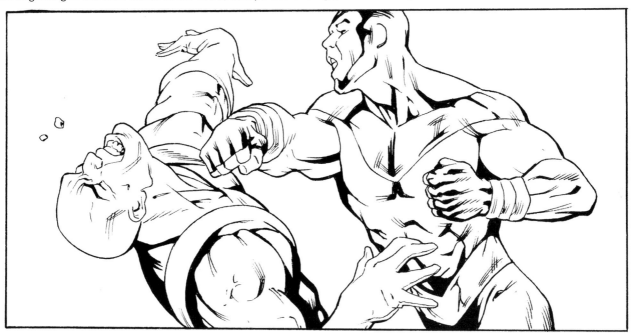

The wind up to a punch counts as part of the actual attack. Remember, it's the intention arrow, as well as the action arrow, that determines the flow of the story.

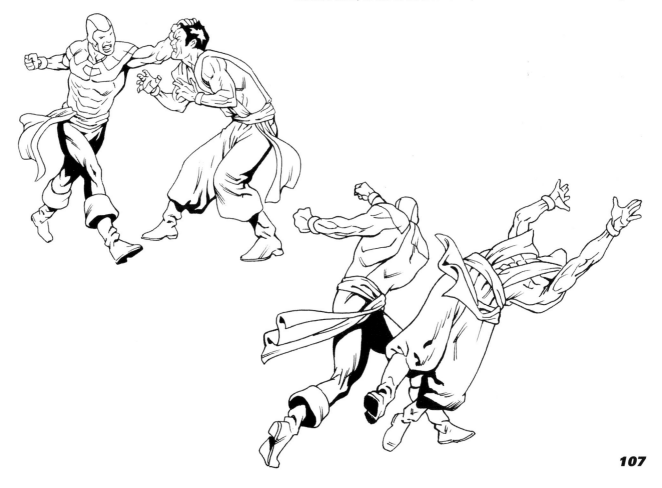

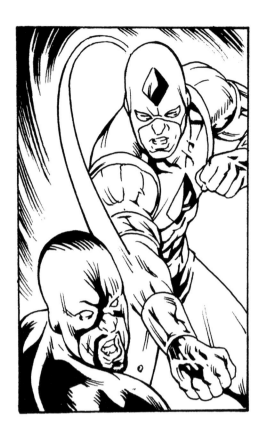

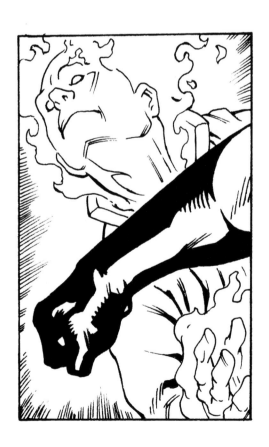

Here are some examples of different strikes in a final attack.

The Finishing Blow

Remember that whatever angle you choose will have an emotional effect on the reader and will sway his or her sympathy one way or the other.

Throughout all these stages, the deeper story of the characters' conflict is the first priority, and you must choose angles that best serve the narrative. You must create a dynamic point of view for the reader. That perspective affects not just how the reader sees the events unfold but how he or she feels about those events as well.

A final blow delivered upward in triumph is different from a blow delivered down on a defenseless opponent.

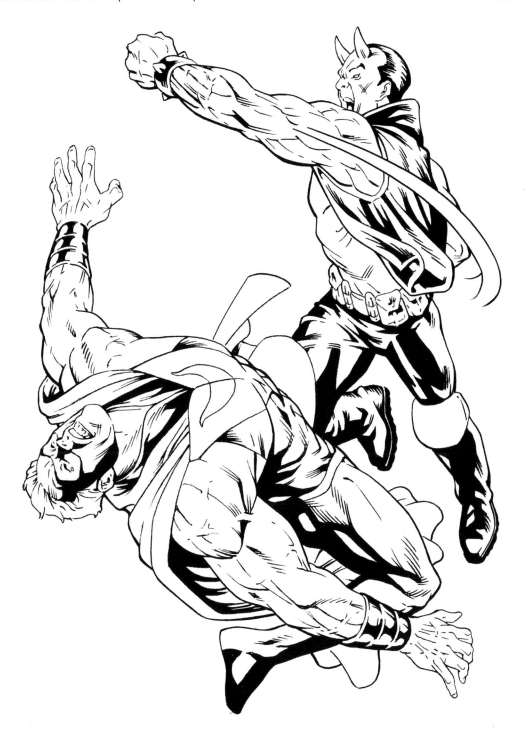

Establishing the New Relationship

With the conflict resolved, we now show the new relationship between our combatants. At this point, their attitude and body posture can explain as much about their character and personality as their behavior did during the fight. Are they compassionate or disdainful? How do they handle victory or defeat? What was the cost of the battle? Are the issues of the conflict resolved? What happens next?

Once again, the angle you choose greatly affects the reader's emotional involvement and reaction. A low angle gains sympathy for the defeated. The reader feels as though he or she is also on the ground.

Below: By tilting a panel, you can lend the sense of weight to the moment.

A top-down angle places the reader above the conflict and has a certain amount of emotional detachment. Though this point of view lacks emotional involvement, it does offer the most spatial information to the reader. It clearly illustrates where all the characters are after the conflict and is also an excellent angle from which to show the effect of a battle on the environment.

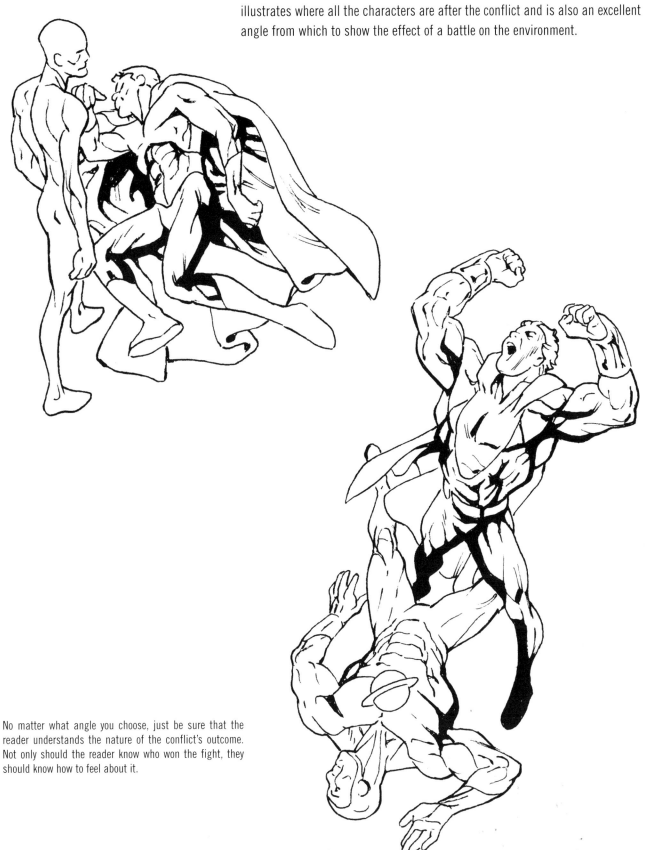

No matter what angle you choose, just be sure that the reader understands the nature of the conflict's outcome. Not only should the reader know who won the fight, they should know how to feel about it.

Types of Fight Scenes: Technical and Emotional

Within the fight scene, there are two separate and distinct types of choreography. A "technical fight scene" illustrates a specific technique, such as a series of complicated martial arts moves, or a set of specific powers. An "emotional fight scene" creates the sense of danger and emotional intensity. So long as the idea and feeling of the fight scene is conveyed, no specific move is necessary. Whether technical or emotional, all moments must be sequential. Even if a movement is not clearly defined instant to instant, the sense of time moving must be conveyed.

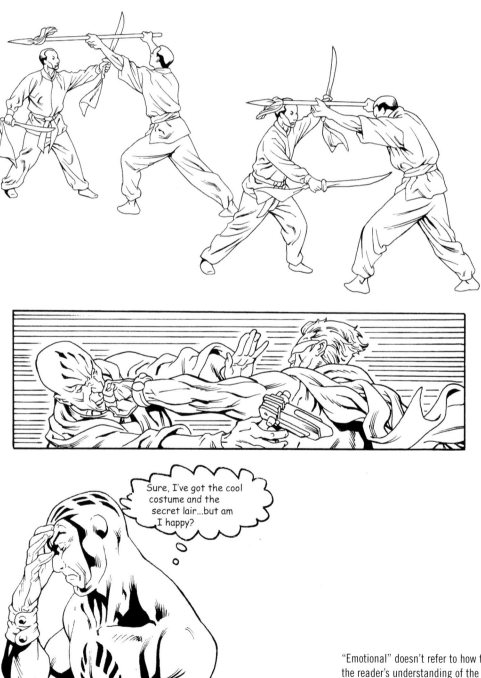

Sure, I've got the cool costume and the secret lair...but am I happy?

"Emotional" doesn't refer to how the character feels but to the reader's understanding of the action.

Here are a series of punches and kicks, shown step by step. This is an example of technical choreography. Each move has a clear cause and effect. The relationship is obvious from drawing to drawing. This may seem dry and emotionally distant, but it is not. Remember, how the characters respond to violence tells us who they are as people. Their movements not only describe the mechanics of the action but also the nature of their personalities.

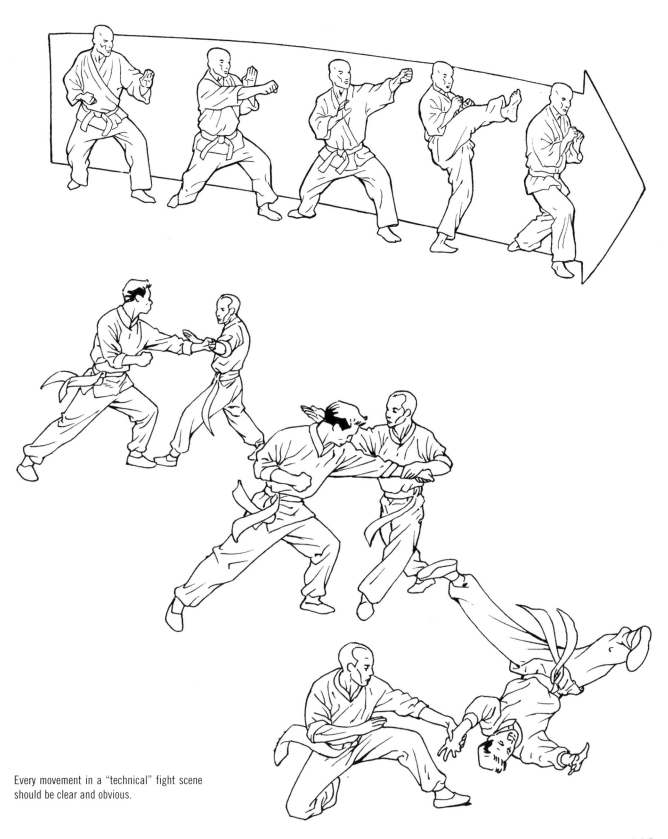

Every movement in a "technical" fight scene should be clear and obvious.

In a moment of emotional choreography only the sense of combat has to be conveyed. You can illustrate the fight scene simply by the direction of the action and the expressions of the characters.

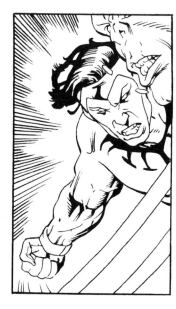

Below are some examples of emotional moments that work very well in a fight scene. None of these are move-specific or even necessarily clear out of context, but they all convey emotion. The visual hint of violence is often more frightening than seeing the act fully drawn. Sometimes it is more powerful to let the reader supply his or her own pictures.

Intense glaring eyes with a serious implication of threat.

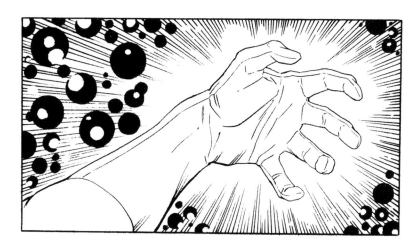

A hand glowing with power, either about to unleash an energy blast or raised in victory.

Blood spraying through the air.

Final Exercise

Below is a segment of a fight scene. Only the middle panel is finished. This panel can be either part of a technical fight scene or an emotional one. For the final exercise of the chapter, finish the empty panels using both types of choreography. Remember, the fight scene is always sequential; one event must follow the next. One moment in time comes after another. In the technical fight the specific movements must be clear and well defined, while in the emotional fight scene just the feeling of the fight must be expressed.

 The ideal fight scene should include aspects of both the technical and emotional scenes. It is through blending the two that an action sequence becomes true storytelling and not just a manual.

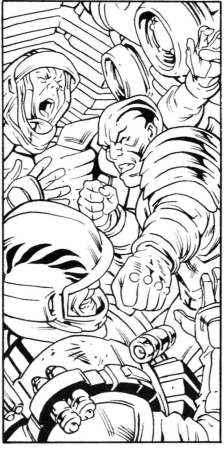

Chapter 8
Putting It All Together

This is where we put all the pieces into place and draw the entire fight scene. In this chapter there will be several examples of different kinds of fight scenes. I'll use diagrams to illustrate the various stages and techniques that we've discussed in this book.

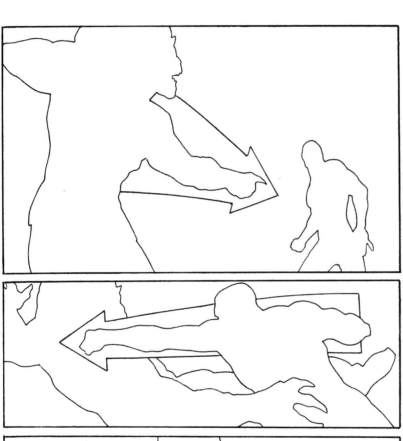

Panel 1: Here we establish the relationships—the spatial relationship between the combatants and their emotional relationship to the reader. By placing the point of view at a low angle near the monster character, we give the reader an immediate sense of involvement. The reader feels as if this guy is towering over him or her.

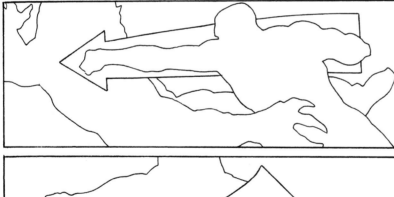

Panel 2: It is not only important to keep the action moving in a manner consistent with the established spatial relationships, but you should also use the flow of action to lead the reader through the story. See how I use the underlying shapes to guide the reader's eye?

Panel 3: The final attack—the last image we see on this page—is the knockout punch. You won't always draw every stage of a fight scene. Pick and choose which stages are appropriate for your story. This encounter was settled by a quick one-two punch. Space is a precious commodity on the page, so give the large panels to the most important moments. In this panel I've broken the panel border to show that the hero's punch is so powerful that his fist comes right off the page.

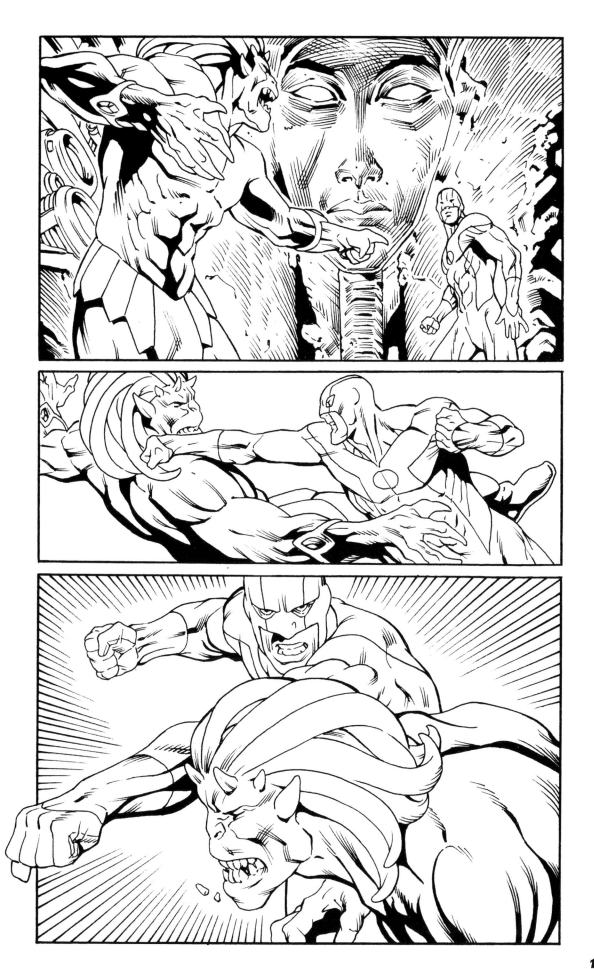

Where you decide to put the camera greatly affects the reader's emotional involvement. By placing the reader's point of view up above the conflict, you create a certain sense of distance and neutrality.

Panel 1: Any aggressive move can qualify as an initial attack, even harsh words.

Panels 2 and 3: By increasing the intensity of emotion, we escalate the encounter.

Panel 4: The reversal—the flow of the confrontation has turned. Even though no move has been made, the direction of intention has reversed.

Panel 5: Remember to keep your characters' spatial relationship to the reader consistent throughout the scene; otherwise, the moment of reversal can be confusing. See how I've added a physical movement and special effect to this superpower?

Panel 6: Establishing the new relationship—by tilting this panel, I've made the side with the victorious figure seem heavier. This lends a sense of weight to the conflict's outcome.

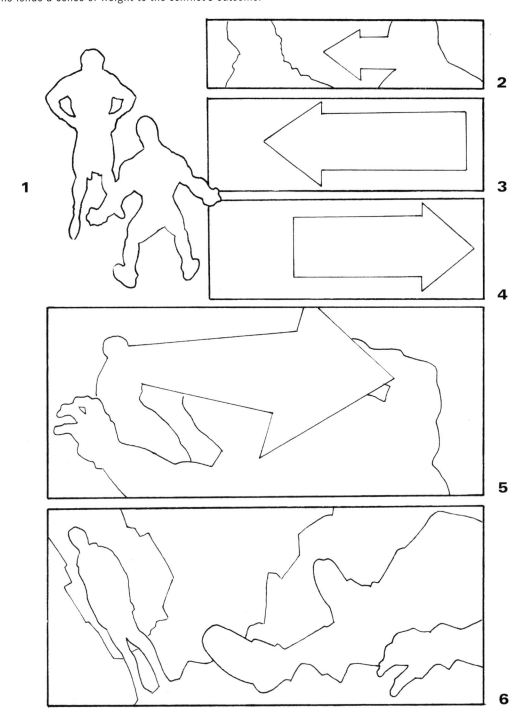

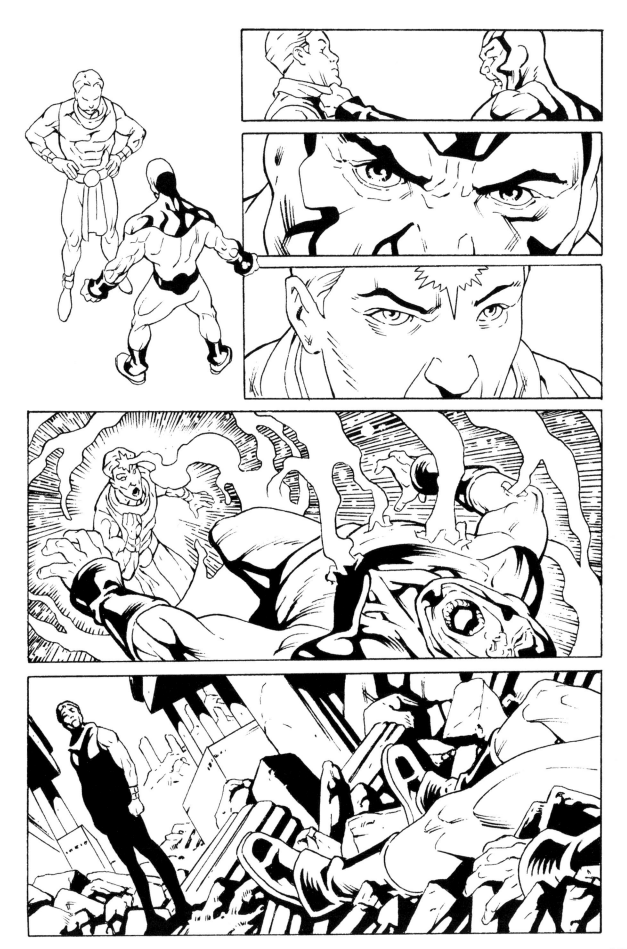

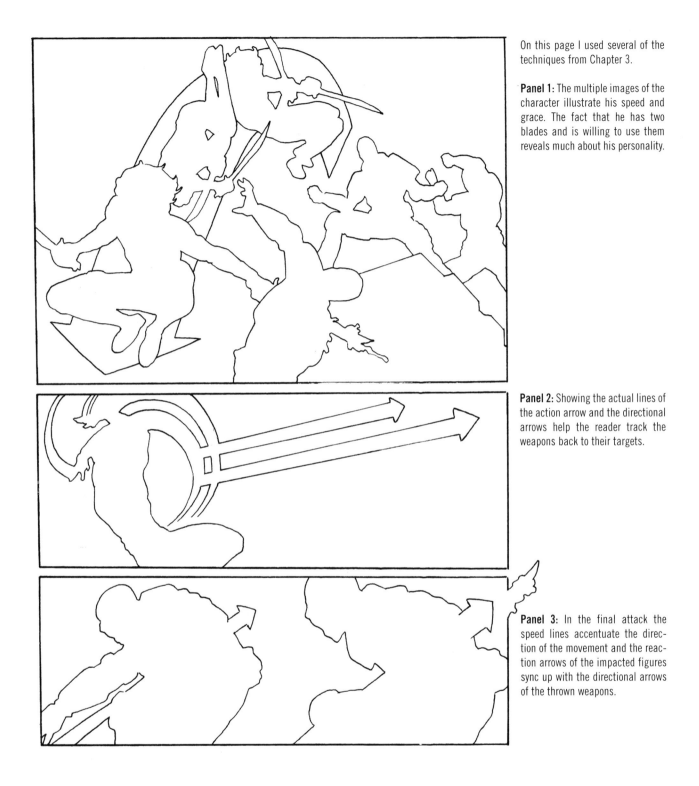

On this page I used several of the techniques from Chapter 3.

Panel 1: The multiple images of the character illustrate his speed and grace. The fact that he has two blades and is willing to use them reveals much about his personality.

Panel 2: Showing the actual lines of the action arrow and the directional arrows help the reader track the weapons back to their targets.

Panel 3: In the final attack the speed lines accentuate the direction of the movement and the reaction arrows of the impacted figures sync up with the directional arrows of the thrown weapons.

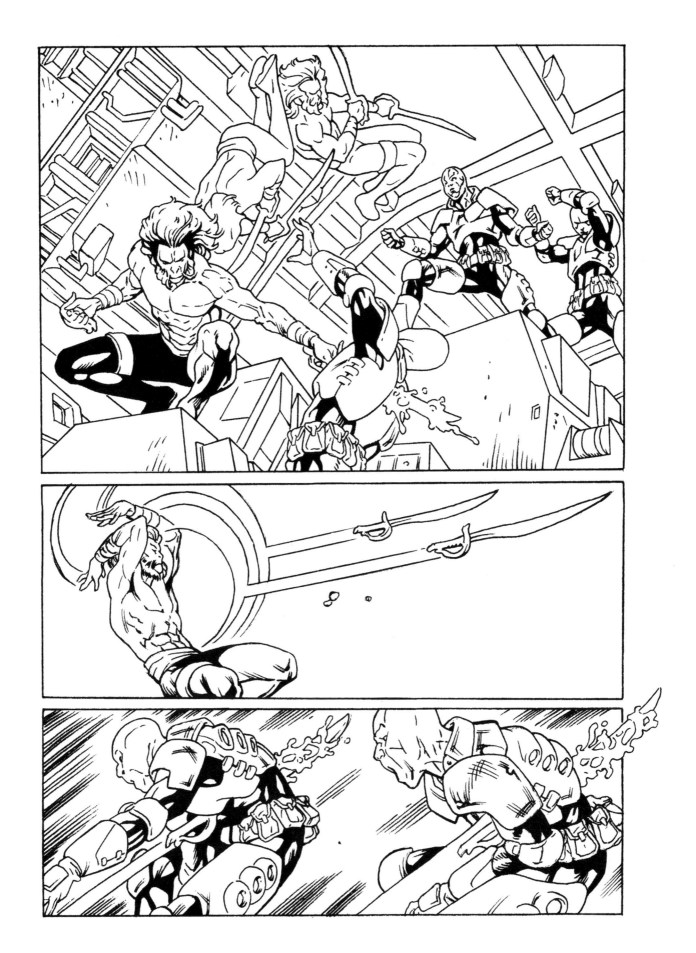

This is an example of a purely technical fight scene. The point of view is placed at eye level, which forces the reader to focus on the specific moves. The similar panel size and shape create the feeling of a uniform passage of time. The sequence has a clocklike rhythm.

Even though they are separate images, the panels seem to be part of one continuous movement.

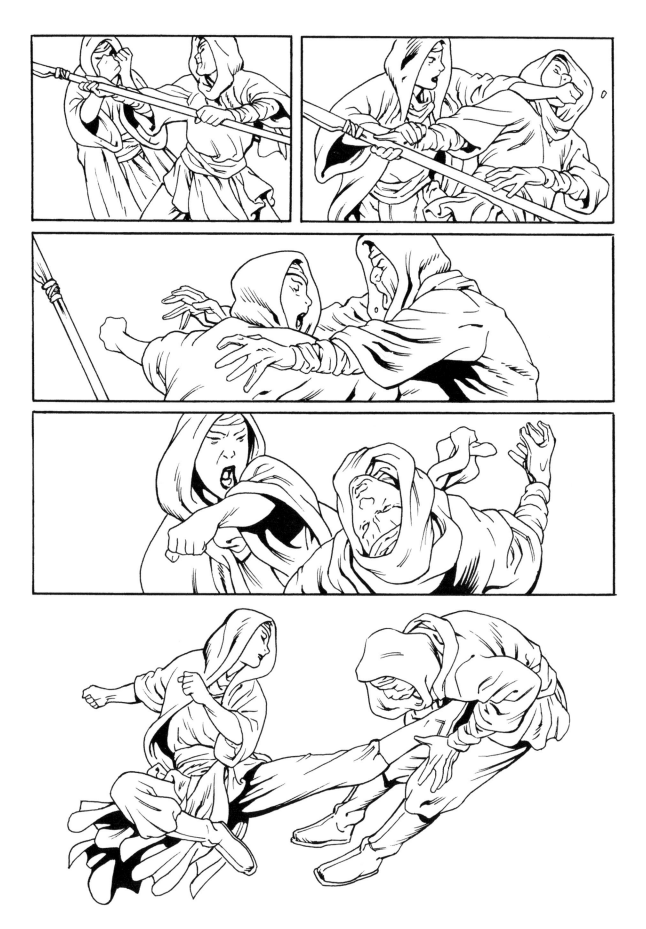

In this emotional fight scene, what is important for this story is not demonstrating a specific technique, but conveying the feeling of being eaten by a giant plant.

Panel 1: I've used the entire left half of the page to get across the sheer size of the plant and placed the point of view low in the panel to give the reader the sense of something looming over him or her.

Panel 2: By moving the camera into the plant's mouth, we allow the reader to get a good look at the character's facial expression.

Panel 3: One way to increase the intensity of the moment is to move the camera closer to the action.

Panel 4: Remember to place readers in harm's way. By splattering them with the plant's sap, you make them feel as if they were actually fighting for their lives.

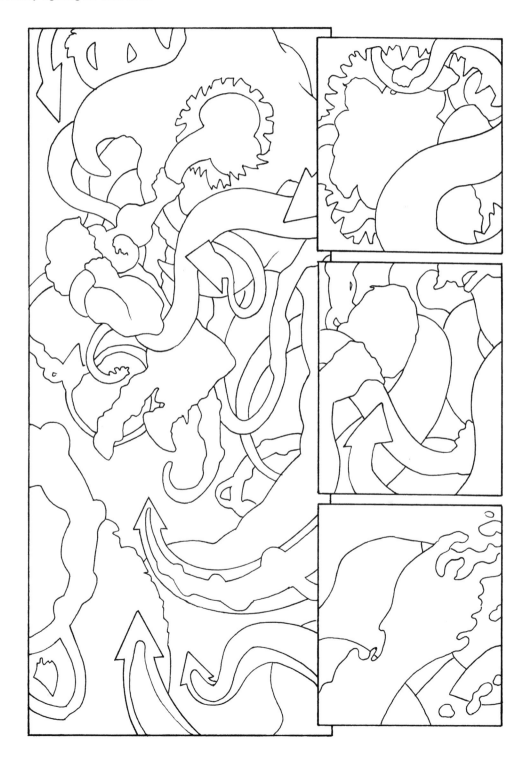

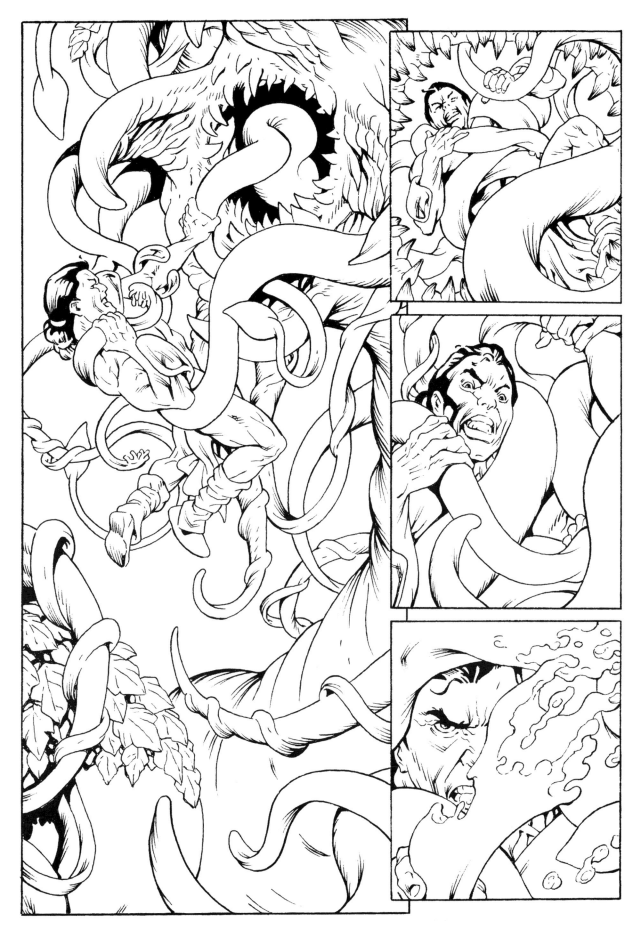

Final Exercise

The artist has to build every moment of the story from the ground up. You have to decide how you want the events to unfold and then choose the best combination of lines to accomplish your goals. Why you draw something is as important as how you draw it.

As a final exercise for this chapter, I want you to deconstruct this fight scene page.

Note the angles I chose in each panel and think about what each position communicates. What techniques did I use to create the illusion of movement? Which stages of the fight scene are shown and which are just implied? Where are the technical and emotional moments?

How would you draw this scene differently? What choices would you make?

Give it a try. Change the panel shapes, change the angles around, and shift the focus of the compositions. Experiment and see what happens.

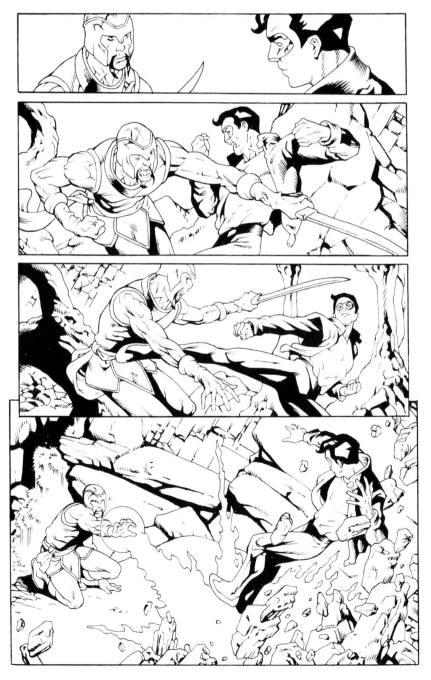

Chapter 9
Other Professionals

The telling of any story is a highly personal and individual process. Just as no two people will ever experience a particular event in exactly the same way, no two artists will ever draw any action or scene in even remotely the same way. One of the reasons we create art in the first place is to attempt to express our singular perspective.

For this chapter, I asked several fellow professionals to draw a fight scene. There were no specific requirements or parameters. Just draw a fight scene. What I received are all highly individual expressions of conflict and its dramatic resolution. These artists differ greatly in training and style; and while the surface aesthetic of their work runs through a wide range of the comic book canon, they all apply the same fundamental techniques discussed in this book.

Even though the final expression of a fight scene will be as unique as the person creating it, the basics of good drawing and good storytelling are consistent and universal.

Scott Kolins

A graduate of the Joe Kubert School, Scott has worked in comics nearly his entire life. Scott's clients include DC Comics, Marvel Comics, Malibu Comics, Dark Horse Comics, Lucasfilms, Chronicle Books, Random House, and Toybiz.

On this page we see Scott's personal creation, ADAM 3.0, fighting a giant cyclops.

Panel 1: The relationship between the combatants and the initial attack are both shown in a single panel. See how Adam follows a directional arrow away from the point of impact? Notice how the underlying reaction arrow accentuates the shape of his figure.

Panel 2: The reversal is shown by Adam's intention arrow. The decision to attack is the shift in the flow of combat. By following the direction of Adam's resolve, Scott has reversed the action.

Panel 3: Two more reversals in one panel. The cyclops' blow directs the action toward Adam; but this time, instead of being thrown along the path of a directional arrow, Adam directs his action arrow back at the cyclops.

Panel 4: In the final attack, the action becomes more focused and escalates. We know the final attack has begun because from this point on the action only flows in one direction.

Panel 5: In this panel, we see the finishing strike. The new relationship between the combatants is implied by the power of the final blow. We know the cyclops is going down and that he's going to crash into the forest below. Since Scott has already shown us what that kind of impact looks like, we, the reader, automatically fill in those undrawn details. This is a prime example of the fifth-dimensional relationship between the artist and the reader. By giving the right information in a certain way, Scott has involved the imagination of the reader and subconsciously invited him or her to fill in the blanks, thus creating the resolution of the conflict together. This fifth-dimensional relationship exists outside of space and time, and while the phenomenon is not exclusive to the comic book medium, it is more controlled and directed here than in any other art form.

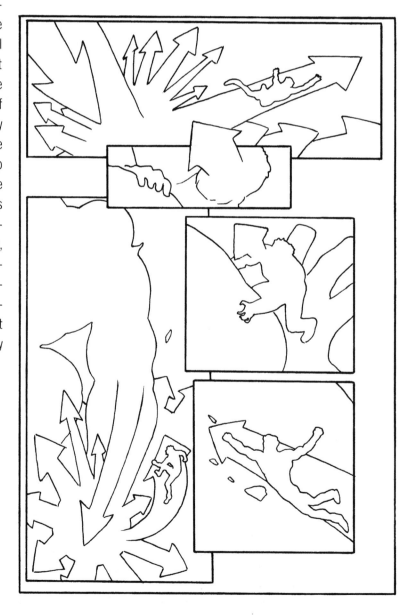

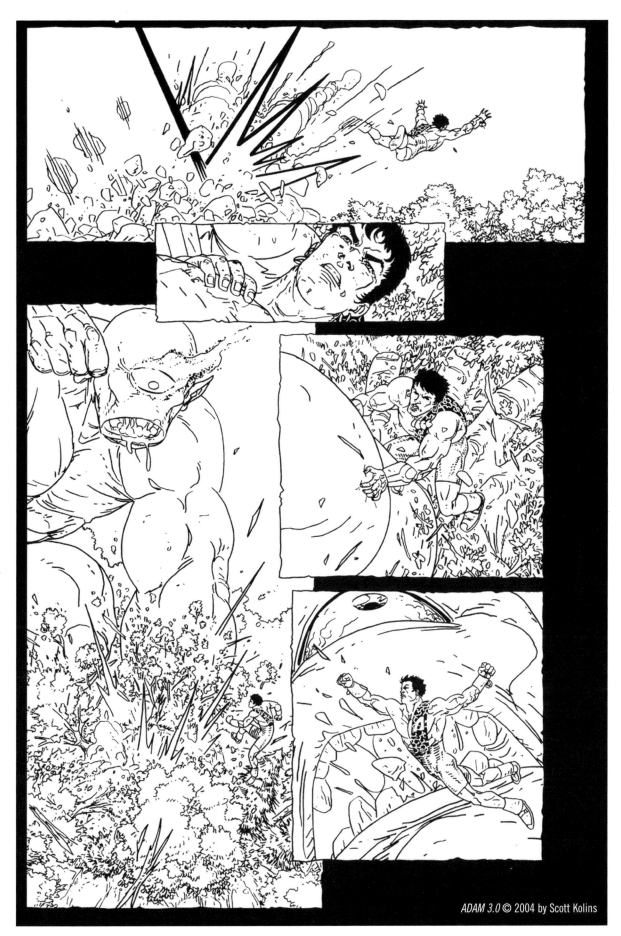

Brandon McKinney

Brandon has worked in comics since before he could walk. He has drawn for Marvel Comics, Image Comics, Elf Quest, Lucasfilms, Chronicle Books, Random House, City of Heroes, and EA Arts.

On this page, we see Brandon's character, Journeyman, battling his nemesis.

Panel 1: Establishing the Relationship. Our two combatants are locked in a stalemate. By splitting the action down the middle of the panel, Brandon has effectively shown us that these two guys are evenly matched. By placing the masked figure on the left, the reader subconsciously feels that he is the dominant player.

Panel 2: Here we have a beautiful example of the initial attack and several reversals. By having an even number of images, Brandon builds on the idea of balance between the combatants. Neither one is really able to gain the upper hand.

Panel 3: In this panel the position of power and the control of the action clearly belong to the masked figure, but Journeyman is far from beaten. See how Brandon uses the multiple-image technique to show a specific move. Since he leads us to the panel's edge and then stops, we get the feeling that our hero will bounce back and continue fighting on the next page.

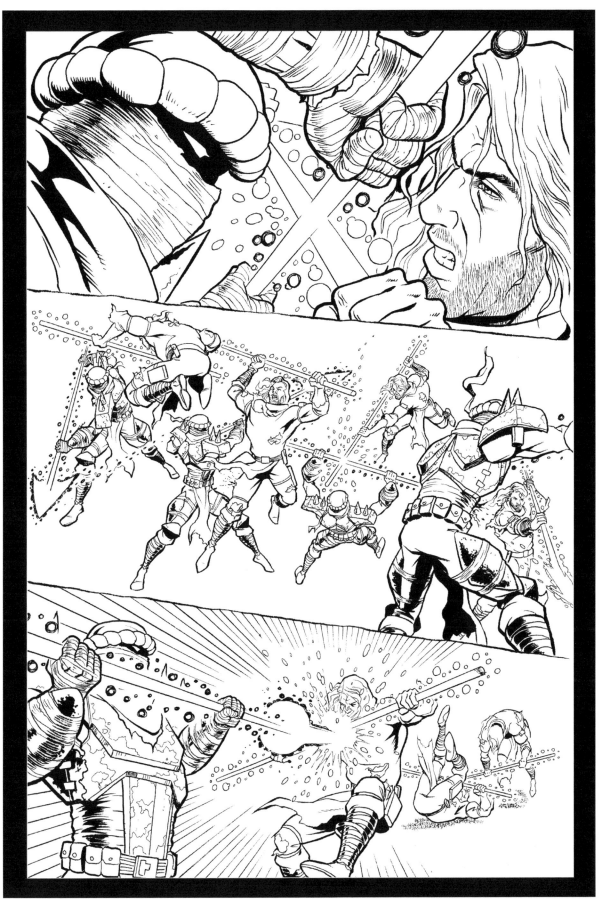

Journeyman © 2000 by Brandon McKinney

Andy Smith

Another graduate of the Joe Kubert School, Andy has worked for DC Comics, Marvel Comics, Crossgen Entertainment, and is the author of the highly acclaimed *Drawing Dynamic Comics.*

In Andy's fight scene we see the pure excitement of a superpowered slugfest. Only in comics can you get this kind of over-the-top action. This is a perfect example of an emotional fight scene as opposed to a technical fight scene. The specific moves are not important, but the feeling of all-out animal ferocity is the goal of the fight scene.

Panel 1: By having the whole left side of the page filled with one image, Andy really makes the reader feel the impact of the blow. Putting the reader right in the action creates an immediate emotional connection.

Panel 2: In a reversal, the action escalates. While it continues to be kinetic and sudden, it is still clear and maintains the reader's emotional involvement.

Panel 3: No one is winning and no one seems to have the upper hand. The action and intention arrows flow back and forth.

Panel 4: Even in the thick of the fight, see how Andy uses the underlying action arrows to help define the shapes and postures of the figures?

Panel 5: By keeping the basic rules of energy transfer and body mechanics in mind, Andy has made exaggerated and over-the-top characters believable and sympathetic. Also, by stacking his panels vertically, he created a sense of falling and urgency in the reader. The fifth-dimensional relationship between the artist and the reader is not just about the co-creation of an image or series of images, but about creating a feeling. It is the emotion that will make the conflict real and give it meaning.

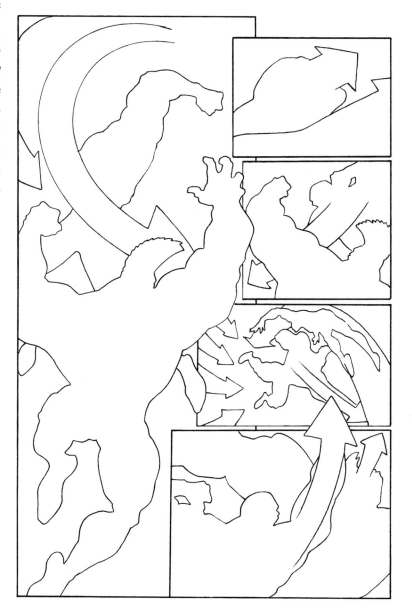

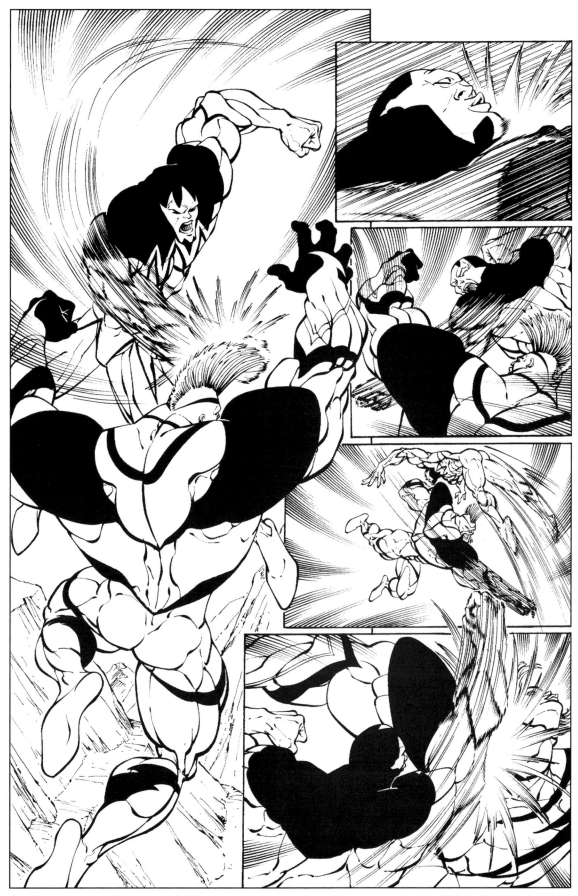

First Man © 2000 by Andy Smith

Steve Jones

Steve has not only worked for DC Comics, Marvel Comics, Malibu Comics, Lucasfilms, Chronicle Books, and Random House Publishing, but has also been an artist on several great animated series such as *Jackie Chan Adventures, The Original Ghost Busters, Batman, Batman Beyond,* and *The Justice League Unlimited.*

On this page, penciled by Steve and inked by another animation veteran, Eric Conettie, we see a beautiful example of a technical fight scene.

Panel 1: Here we have the establishing of the relationship and the initial attack combined into a single image. These two stages are often joined due to the constraints of space and the scene's individual priorities. Steve shows us everything we need to know about the combatants by how they are drawn and how they are moving.

Panel 2: The goals of a technical fight scene are twofold: to show the sequence of a specific move or a series of moves, and with those moves to describe the nature and personality of the character.

Panel 3: In this panel Steve clearly demonstrates the effective use of a judo hip throw.

Panel 4: The attacking brute is carried along the trajectory of his own action arrow.

Panel 5: The action continues from the right side of the page for the entirety of the scene and is never actually being reversed by our hero. This gives us the feeling that the attacker defeated himself. By choosing this particular response to this attack, our hero reveals more about his personality and nature than a conversation ever could.

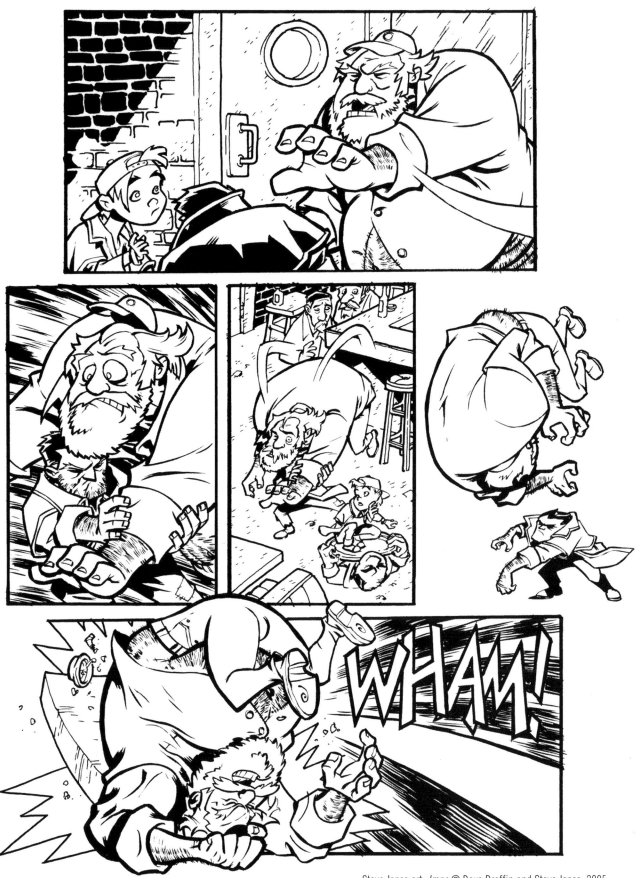

Steve Jones art. *Imps* © Dave Draffin and Steve Jones. 2005

Dan Panosian

Dan has done work for DC Comics, Marvel Comics, Image Comics, Wildstorm, and Dark Horse Comics. His other credits include toy design, movie concept art, advertising, storyboarding for live action and animation, and designing characters for video games and animated films.

Panel 1: In Dan's fight scene the reader joins the event in the middle of the action. Dan immediately creates an emotional bond to his hero by placing her alone in the panel and in obvious jeopardy. Her intention arrow leads us right out of the panel. Without any linear information to absorb, we automatically increase our mental speed across the page. This gives us the feeling of a quick turn and a sudden drop into the next panel.

Panel 2: By loading this panel with dense linear information, Dan has ground our reading pace and, therefore, our sense of time to a halt. He has forced us to linger on this panel and really take in the nature of the threat. Giving two whole panels to the establishing-the-relationship stage of the fight scene increases our emotional connection to the character.

Panel 3: In this panel is the initial attack. Even the shapes of the background and foreground are attacking our hero. We really get the sense that she is surrounded and in serious danger.

Panel 4: The reversal—that's all we need to see. The action and intention of the panel continue off the page, and we know that she is going to win. The final attack and the re-establishment stages aren't even necessary. See how Dan uses the action arrow and the directional arrow of the sword strike to determine the body posture of the figure being cut? The basic fundamentals of figure interaction are used by everyone and understanding them will make your fight scene believable and engaging.

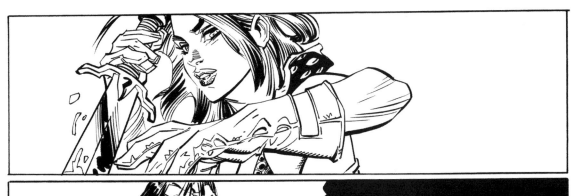

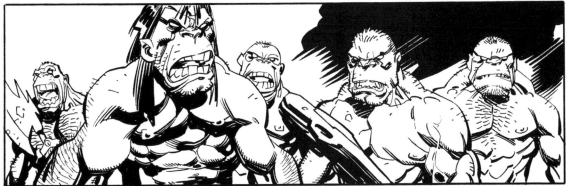

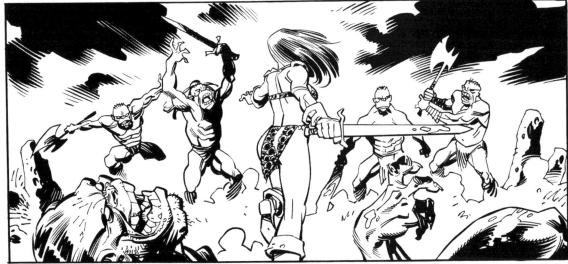

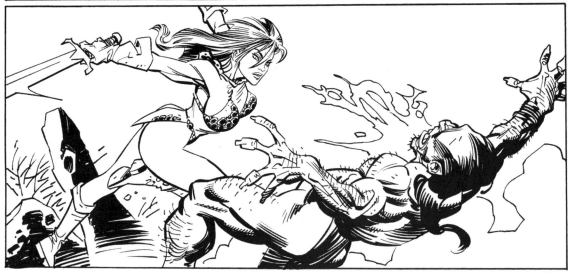

Joaquim Dos Santos

Joaquim has worked on several animated shows, including the *Teen Titans, Men in Black, Starship Troopers,* and *Justice League.* He is currently a director on the hit series *The Justice League Unlimited.* In his contribution he shows us that one picture is worth a thousand words.

In this splash page he has combined several fight scene stages into a single image. The relationship between the combatants, the initial attacks, and even a reversal or two are obvious in this one drawing. The composition itself actually does the job of individual panels. By beginning in the upper left-hand corner and driving the action down and to the bottom right of the page, Joaquim not only moves us through space, from the background to the foreground elements, but through time. We see what just happened at the top of the page and can imagine what is going to happen at the bottom of the page.

See how the shapes of the figures follow their underlying action arrows? Note how Joaquim has used the body postures to direct the eye toward the main conflict. This is a very complex scene with many layers, but by using the action and intention arrows, he has made the melee clear and exciting.

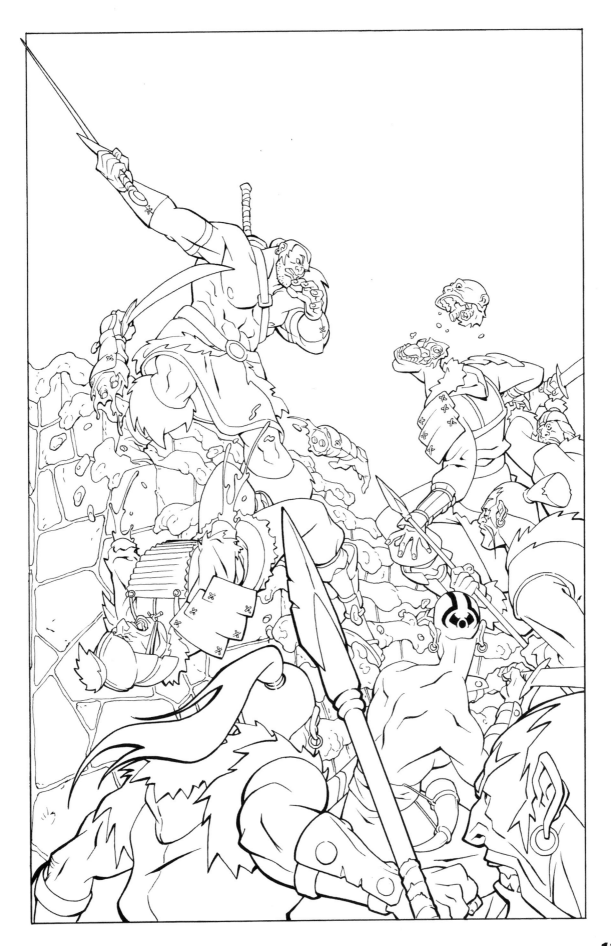

Chris Schenck

Chris has done work for Lucasfilms, Chronicle Books, Random House Publishing, and EA Arts, and has also been a storyboard artist on the *Batman* and *Batman Beyond* animated series. He has been the head designer on several video games and is a teacher at the San Francisco Academy of Art.

In this textbook example of good storytelling, Chris has divided his panels by the corresponding stages of the fight scene and composed his shapes in a way to move the reader fluidly down the page.

Panel 1: Here he establishes the relationship between the character and sets the scene.

Panel 2: The angle of the initial attack is not only consistent with the combatants' established spatial relationship, but it also leads the reader's eye into the next panel.

Panel 3: In the reversal in this panel, the flow of action now moves from left to right. The tide of battle has shifted. See how the various combat arrows line up to really sell the power of the punch?

Panel 4: In the final attack Chris gives the character's weapon movement and purpose.

Panel 5: The establishment of the new relationship.

Chris's page not only demonstrates the 5 different stages of a fight scene beautifully, it also shows that not all conflict has to end badly.

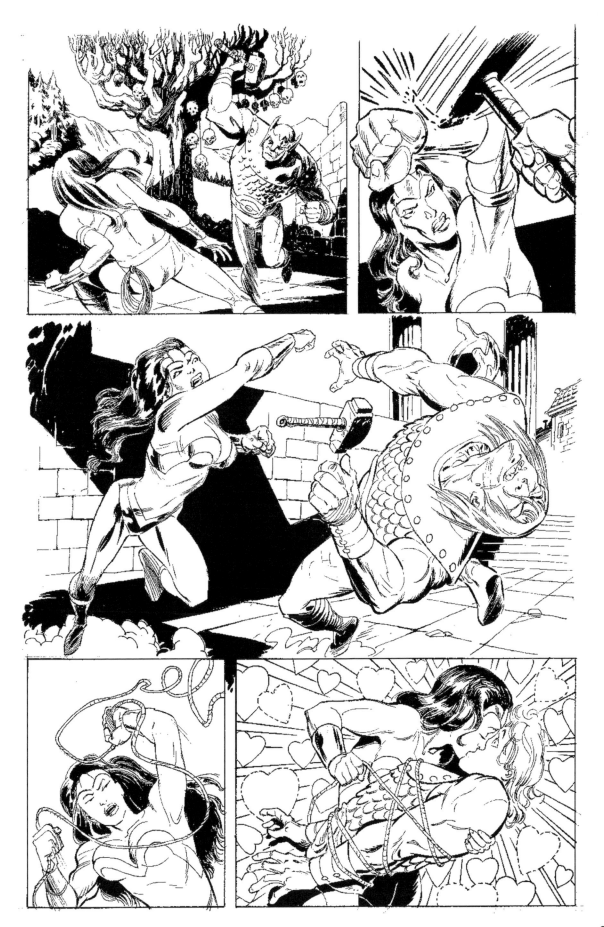

The Finishing Touch

Sixty percent of all communication is nonverbal. We relate to our world and each other through the way we move and what we do. We express our personalities and philosophies through our actions. This is truest when we find ourselves in the middle of a confrontation. How we resolve conflict defines us as a person. Our response to violence reveals the quality of our character, our beliefs, and our ideals.

In the absence of actual combat, our stories are how we express those ideals.

Whether it's personal or grandiose, all stories are fundamentally about the nature of conflict and its resolution. The fight scene, while just one piece of any story, also stands as visual metaphor for that core conflict. And as such, the specific techniques used during a fight scene are more than just the mechanics of combat—they are manifestations of narrative themes.

When thought of in these terms, the fight scene becomes more than just an interesting device. It is a summary of the story as a whole. It can express different philosophies in clear and dramatic images. A well-executed fight scene can elegantly illustrate the struggle between opposing ideas and make something as ugly as violent confrontation into something graceful and beautiful.

To master any physical technique requires ten thousand repetitions, and to draw something well requires constant practice. We've covered a lot of ground in this book and some of your drawings may not have been as satisfying as others. But you can learn as much from a bad drawing as you can from a good one. Just stay in the moment, do each step in its proper order, and practice. Eventually the ability to draw what you picture in your mind's eye will become easy. And once you can give life to your imagination—anything is possible.

INDEX